Charles Reid's Watercolour Solutions

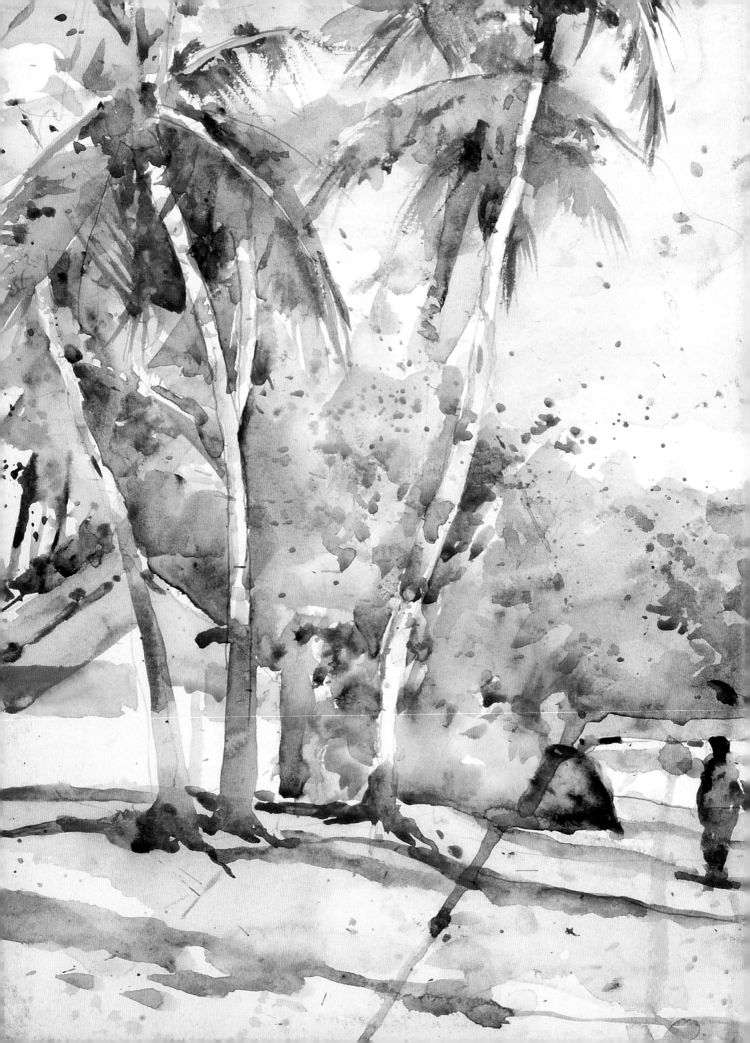

# Charles Reid's
# WATERCOLOUR
# SOLUTIONS

## Learn to Solve the Most
## Common Painting Problems

D&C
David and Charles

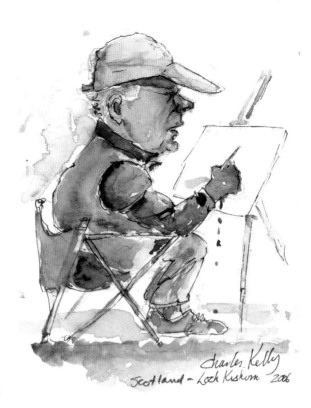

Scotland – Loch Kishorn 2006
Charles Kelly

## ABOUT THE AUTHOR

Charles Reid is an award-winning artist specializing in watercolour painting.
He teaches too many classes and workshops, but they constantly refresh him.
Thinking of new ideas for each class is hopefully warding off Alzheimer's.

Charles exhibits in both the United States and Europe, meeting many talented and
delightful people while travelling with his best friend and wife, Judith.

A DAVID & CHARLES BOOK

David & Charles is an F+W Publications Inc. company
4700 East Galbraith Road
Cincinnati, OH 45236

First published in the UK in 2008
First published in the USA by North Light Books Cincinnati, Ohio

Copyright © Charles Reid 2008

Charles Reid has asserted his right to be identified as author of
this work in accordance with the Copyright, Designs and Patents
Act, 1988.

A catalogue record for this book is available from the British
Library.

ISBN-13: 978-0-7153-2708-1 hardback
ISBN-10: 0-7153-2708-9 hardback

Printed in China
for David & Charles
Brunel House    Newton Abbot    Devon

Visit our website at www.davidandcharles.co.uk

David & Charles books are available from all good bookshops;
alternatively you can contact our Orderline on 0870 9908222 or
write to us at FREEPOST EX2 110, D&C Direct, Newton Abbot,
TQ12 4ZZ (no stamp required UK only); US customers call
800-289-0963 and Canadian customers call 800-840-5220.

Edited by Vanessa Lyman and Jeffrey Blocksidge
Designed by Guy Kelly
Production coordinated by Matt Wagner

## Metric Conversion Chart

| To convert | to | multiply by |
|---|---|---|
| Inches | Centimeters | 2.54 |
| Centimeters | Inches | 0.4 |
| Feet | Centimeters | 30.5 |
| Centimeters | Feet | 0.03 |
| Yards | Meters | 0.9 |
| Meters | Yards | 1.1 |

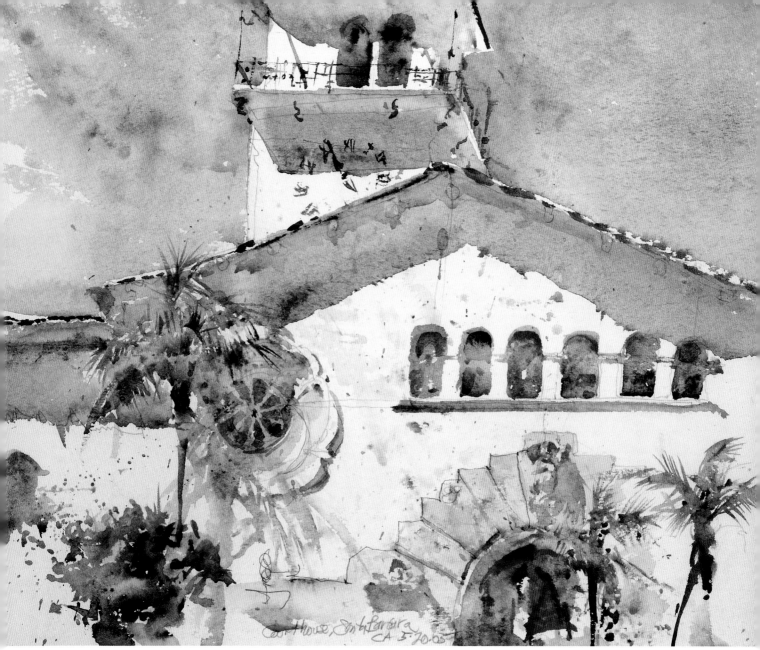

**Courthouse, Santa Barbara**

ACKNOWLEDGEMENTS

Thanks to my editors, Jeffrey Blocksidge and Vanessa Lyman, and all of the very talented people at North Light who worked so hard to make this book possible.

Also thanks to all of the friends and students who gave me ideas and support. Sadly we weren't able to include so many of their worthy paintings. Even though your paintings don't appear in the book, they gave me inspiration.

DEDICATION

To Judith, as always.

And to my parents, David and Peggy, and my brother Gorden, who always encouraged me.

# Table of Contents

*Lose yourself, your memory and your wish to be "correct."*
*Learn to paint people objectively, using value to communicate*
*their features and skin tones.*

*Learn to interpret light and shadow, to build contrast, and to*
*simplify and connect shapes of value to paint engaging scenes.*

**Joseph Wolfskill—Scottsdale**

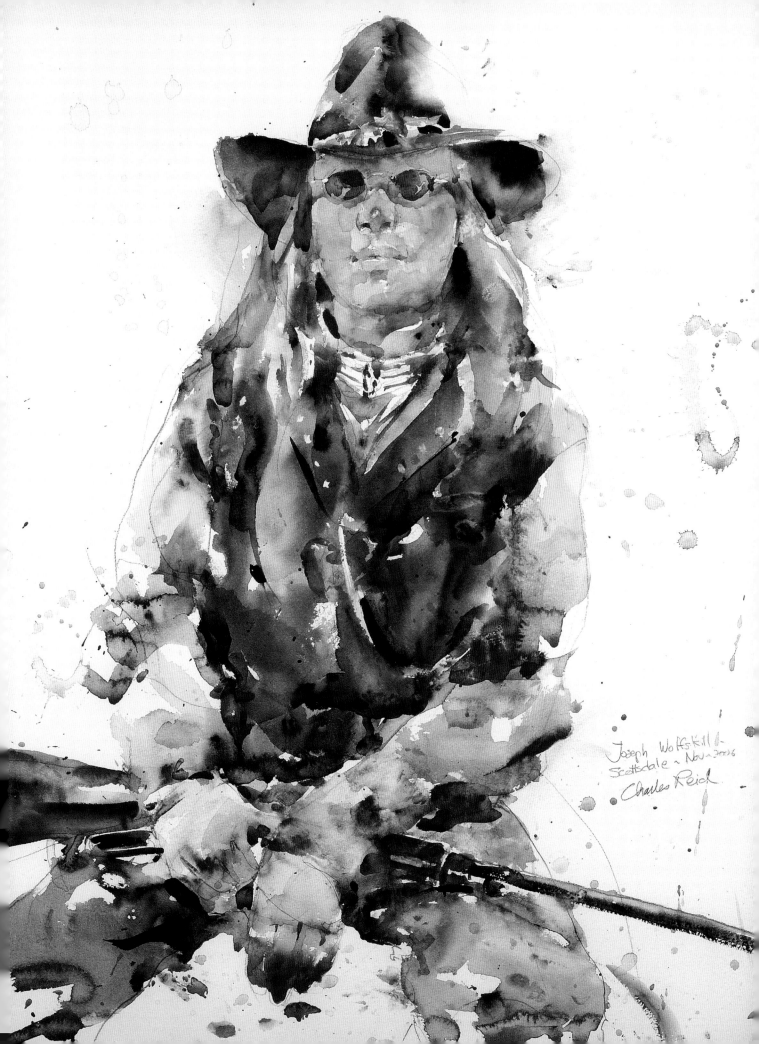

Joseph Wolfskill
Scottsdale ~ Nov 2006
Charles Reid

# Introduction

HOPEFULLY YOU'LL FIND SOME TIPS IN THIS BOOK that will help with your watercolor painting problems. My advice: Practice contour drawing, stop sketching and always have wet paint in your supply.

Try to enjoy the small victories. Stop painting when you no longer have ideas. Remember, all watercolors painted on the spot will have flaws. Enjoy painting and don't dwell on the result.

I've taught many classes and I've tried to remember and deal with the most common problems discussed in critiques over the years. I most likely missed some important problems and I apologize. But let me start you off with some basic rules to live by:

## Learn to Draw
Study my exercises, especially my contour drawing of the Talbot motorcar on page 14. Don't just look at the pictures. Drawing is the key to figure work, but it's just as important in still-life and landscape painting.

## Learn to See Values
Don't confuse values with color or color intensity. Before using color, paint the examples in monochrome with Payne's Gray using the value scale on page 20. Find old photographs with apparent light-and-dark differences. Avoid photos that have confusing half-tones (middle values between light and shadow).

## Don't Copy What You See
Digest what you see into your own vision. Don't just see and paint. Remember "The Magic Squint": If it's hard to see a boundary when you squint, then it's a lost edge. (Thanks to Richard Schmid for this term.)

Always evaluate a painting decision with an adjacent element. Never draw or paint anything isolated.

**Joseph Wolfskill 2—Scottsdale**

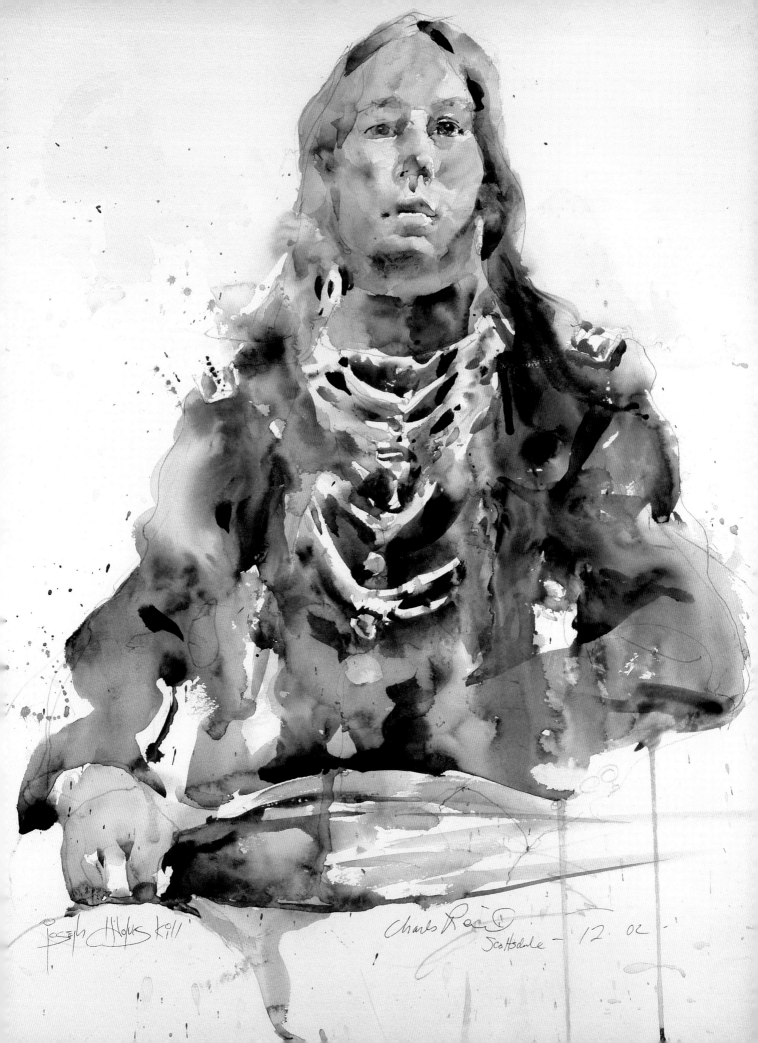

Joseph Hawks Kill

Charles Reid

Scottsdale — 12. 02 —

# Brushes, Paper and Other Stuff

## Brushes

Brushes are your most important consideration. You can use cheap paper, plastic palettes and student-grade paints, but you must have good brushes. There are four choices when choosing a brush: natural sable hair, natural hair from other animals, a combination of sable hair and synthetic fibers, and completely synthetic fibers. These brushes come in two shapes: round and flat. I use only round natural sable brushes (often labeled *kolinski*, after the little animal whose tail is used to make sable brushes). Although I'm not qualified to comment on the other brushes mentioned above (I've never used any of them), I will make some observations. Synthetic brushes are inexpensive, but they don't seem to hold much water and paint. Squirrel quills hold lots of paint and water, but they're rather lank and lack spring, and they're almost as expensive as sables. If you can't manage a natural sable, a round brush with a mix of natural and synthetic fibers would probably be your best bet.

There are many fine natural sable brushes available. You can purchase them from any artists' catalog. Sable brushes can seem very expensive when compared

to synthetic brushes, but I've found that a good sable brush will last and give you more painting pleasure than synthetic brushes. My favorite is the Da Vinci Maestro. It has a very full body and points beautifully.

A no. 8 would be a good size to start with. This is the size I use the most. Once you've made the plunge and decide to purchase another brush, I'd backtrack and buy a no. 6. If you're delighted with your sable brushes, you should add a no. 10 to your next Christmas or birthday wish list. I use a no. 12, but you really don't need a sable larger than a no. 10. If you are painting a large area and need a big brush, use a squirrel quill or sable/synthetic brush.

## Paper

Watercolor requires a different surface from oil painting. Oil painting is usually done on canvas, a passive surface that doesn't absorb paint. Each stroke stays put unless the painter changes it. Watercolor paper is a dynamic surface. The paper is alive and can create parts of the painting on its own; the painter has to deliver the right amount of paint and water to the right spot.

Watercolor paper comes in three thicknesses (or weights): 90-lb. (190gsm), 140-lb. (300gsm) and 300-lb. (640gsm). The only weight I use is 140-lb. (300gsm). Watercolor paper also comes in three surface types. Hot-pressed (smooth) is fun to work with if you're an experienced painter. It's at its best with first-stroke painting, but it doesn't like corrections. Cold-pressed (moderate tooth or texture) is the most commonly used and the paper I'd suggest. Rough (pronounced tooth or texture) behaves the same as cold-pressed; it just has more texture. I suggest you buy a couple of sheets of each with which to experiment.

Most of my students use Arches brand paper. It's a durable paper that takes punishment, lifting and correcting in stride. I've never used Arches paper, but this is a personal choice.

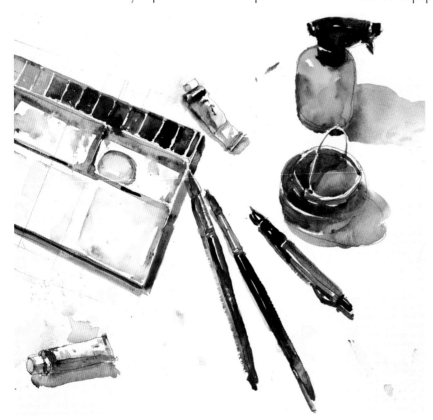

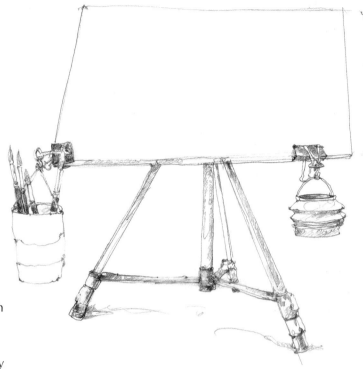

### En Plein Air

This shows my en plein air setup, which is quite portable. My drawing board is attached to the photo tripod. The tripod can be adjusted easily for height and for the board's angle.

My best recommendation is to try Arches or stick with whatever paper you're used to.

Fabriano, Whatman and Waterford are softer papers. They don't take corrections well, but they accept paint readily and are very receptive to my "first-try, no-corrective-overwashes" way of working.

I've noticed that students do some of their best painting on cheap paper. Students also do best when they work small. I think working on a small piece of inexpensive paper makes the painting less of a production, and more of a relaxed, enjoyable painting experience.

## Other Stuff

Most of the people who come to my classes are serious painters, but they have families and careers and can't be full-time painters. Often they don't have studios and must pack up after each painting session. The materials I'm suggesting are what I use, with mobility in mind.

**Spray bottle.** You need to keep your paint moist while painting. Some colors dry before others and there will be colors you're not using much that may need a squirt. If you haven't painted lately, spray your palette a half hour before starting. Most colors will come to life unless you haven't painted for months. If your colors have turned to little chunks, they can't be resuscitated and must be discarded.

**Battery-powered pencil sharpener.** You need a sharp pencil for contour drawing.

**Clips or masking tape.** Use these items to secure your paper to a board. Black bulldog clips with folding handles are handy when packing your work in a portfolio.

**Kneaded eraser.** Common erasers often disturb the paper. I use a kneaded rubber eraser. These erasers clean smudges as well as erase lines. Make sure your eraser is clean. (I store mine in an empty film canister.)

**Pencils.** Use sharp graphite pencils; HB, B and 2B are fine. I also use regular 2B office pencils. Avoid charcoal and carbon pencils because they tend to smudge.

**Water containers**. I attach my water containers (I use Holbein's) to the metal loop on my folding easel. You'll have to use some ingenuity to find a water container that you can fit to your easel. Each easel will need a different solution, but you should work out a system that allows you to have your water, palette and painting surface within inches of one another.

**Drawing board.** Make sure your drawing board is a good size for you to handle.

**Easel.** A collapsible metal easel is your best bet. I haven't used a metal easel, but there are several I've seen in my classes that are light and sturdy. Ask your painting friends which easels work best for them.

11

# Pigments and Palettes

Arrange your palette properly. Never squeeze a few haphazard colors into your mixing area. The colors on your palette must have an order so you know exactly where to find a color without searching. With practice, your brush will go to a color as naturally as your fingers go to a key on your computer keyboard.

Place blues, reds, yellows and earth colors in separate sections of the palette and arranged according to each color's value. I think of colors as belonging to nuclear families that merge into extended families.

I like to mix my greens, allowing myself two slots for premixed greens. If I were painting a green that's cool, I'd use Viridian or Hooker's Green. If the green were neutral or grayish, I'd use Oxide of Chromium. If the green were warm, I'd use Olive Green.

I primarily use watercolors from Winsor & Newton and Holbein as well as Sennelier, Schmincke and Old Dutch. You'll see price variations among these brands but all of them have equally high standards regarding permanence and all rate their colors honestly, often in four categories from permanent to fugitive.

Colors do vary from one brand to another. You can't be sure that one maker's Cadmium Yellow or Cerulean Blue is exactly the same temperature and value as another brand.

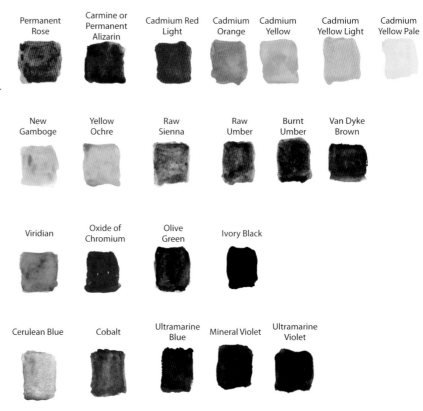

## My Palette Colors

I always include Carmine (Holbein) or Alizarin Crimson for my red. Always an earth-color for yellow. (Yellow Ochre and Raw Sienna are so close you could always use Raw Sienna for light and mid-value mixes, but I have both.) I start with Yellow Ochre (for the lightest mix), then Raw Sienna (mid-value mix) and Raw Umber (darkest mix). For blue, I always include Cerulean Blue (for the lightest mix), Cobalt Blue (mid-value mix) and Ultramarine Blue, Mineral Violet or Ultramarine Violet (darkest mix). I use Permanent Rose mostly for flowers.

## Don't Overload the Palette

Don't overload the palette slots with paint, especially if you're not painting regularly. If the paint dries out and becomes extra crumbly, it can't be saved. Put out only small amounts in the slots. If you paint regularly, but skip a week occasionally, put a damp paper towel in your palette.

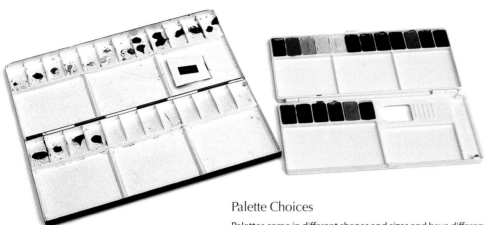

## Palette Choices

Palettes come in different shapes and sizes and have different well arrangements. A palette's wells are designed for squeezed tube colors or for half-pan cake colors. Wells are the slots around the edges of some palettes and in the centers of others. The flat parts of your palette are your mixing areas.

Large plastic palettes are fine for studio painting when you have a table available. The palette, water, tissues and brushes should be within close, easy reach.

When you're in a class or on location, you probably won't have a table. The big palette becomes awkward as you lean over to your side to mix, and it may be hard to really judge the values and colors. A hand-held palette is much handier.

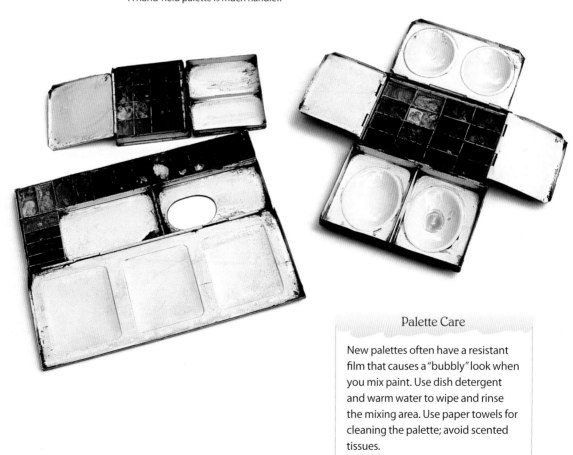

### Palette Care

New palettes often have a resistant film that causes a "bubbly" look when you mix paint. Use dish detergent and warm water to wipe and rinse the mixing area. Use paper towels for cleaning the palette; avoid scented tissues.

# Contour Drawing

For almost all of my paintings, I make an initial drawing using a modified blind contour drawing method. In traditional blind contouring, you don't look at your drawing as you draw; you keep your pen on the paper, and your eyes on the subject. The entire drawing should be done with one single line. Blind contour drawings are a wonderful way to activate the right side of your brain and free yourself from being "correct."

I liked the concept of blind contouring, but wanted to make single line images that were more accurate. So I changed the ground rules. I still keep the pen or pencil on the paper, never lifting, but I often stop the pen or pencil as I look up to check the contour of my subject in relation to other shapes. I especially look for distances and angles, making a dot as I stop, like a runner jogging in place. Once I've decided the angle of the line and how far I need to go before changing direction again, I can continue.

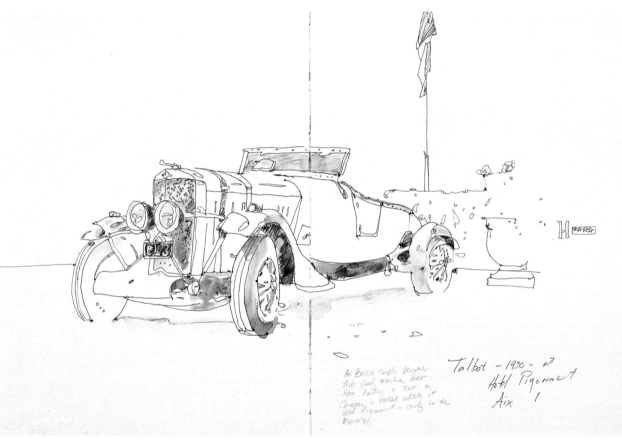

**1930 Talbot Motorcar**
**Hotel Pigonnet, Aix**

## Capturing Classic Contours

I made a drawing of this 1930 Talbot motorcar early one morning. An English couple had driven it over and I wanted to draw it before they left. The modified blind contour drawing was the perfect way to do it. Later, I used Payne's Gray to shade the original sketch. The spontaneity of this sketch captured the rakish beauty of the wonderful machine.

# Modified Blind Contour Drawing

This is a very important exercise because it can help you get into the right side of your brain. Ideally, you'll forget the identity of the object you're drawing. Instead you'll concentrate on shapes, connections and the angles and distances your pen will travel to create a new shape.

## 1 Keep Your Eye on the Subject

Use any pen but not a pencil. I want you to concentrate, but not be able to correct. Keep your pen on the paper, even when you stop to check the direction of your line. Pretend your pen is on the object you are drawing. Draw slowly.

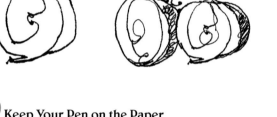

## 2 Keep Your Pen on the Paper

Use a single line, drawing slowly, with the underside of your hand resting on the paper to keep your hand steady. Hold the pen just as you would when writing. You need absolute control. Resting your hand on the paper also will help you avoid lifting your pen.

## 3 Use a Single Line

It is important to use the same line as much as possible. Use this line to draw the inside shapes as well as the outer shapes, dipping into the outline to capture the shapes found there. "Inside" and "outside" should always be thought of as one.

# Brushwork

## Test Your Brushes

When you order a brush, be sure to try it out immediately. It should form a good point when wet. Dip the brush in water, give it a shake and make a stroke using the underside of the brush, then lift. The brush should spring back to nearly its original shape. If the brush is too dry, it probably won't spring back. Try different amounts of wetness in the brush. If it doesn't point well or doesn't spring back, return it.

## Basic Strokes

There are four steps involved in bringing paint to the paper: rinse the brush, give the brush an abrupt and definite shake, dip the brush in the moist paint supply, then put the brush to the paper. If your paint is "dry-brushy," you may need to give a less definite shake. Spend some time with getting to know various water-to-pigment ratios.

Start the stroke with the brush tip and then press down to paint using the underside of the brush. Never paint with the tip of a sable brush; concentrate on painting with the middle section of the brush.

Keep your brush on the paper as long as possible. Keep the underside of your hand, your knuckle, or the tip of your little finger in contact with the paper when painting. This will help you avoid lifting. Always keep the tip of your brush in sight.

### Make Your First Effect Your Best

Try to achieve the correct color and value with your first effort. Never try to correct a color or darken a value when a first effort is only partially dried. If an area needs restating, it must be totally dry before correction.

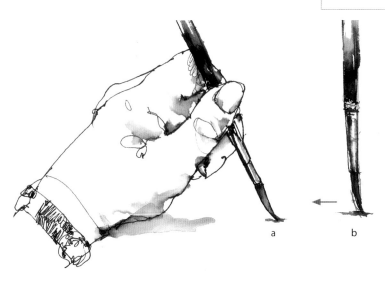

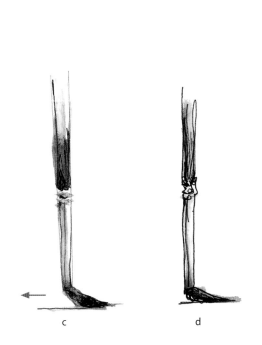

**Basic Stroke With the Underside of Your Hand Against the Paper**
Rest the underside of your hand on the paper.

- **a.** Point the tip of your brush on the paper.
- **b.** Begin to press the tip.
- **c.** Press.
- **d.** Paint your stroke using the underside of the brush. Sometimes you'll press only halfway down; other times, with a broader stroke, you'll paint down to the ferrule.

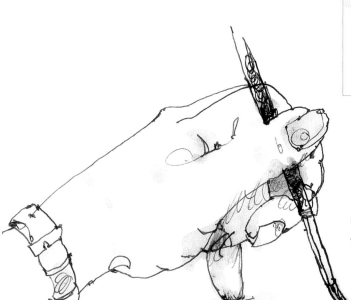

### Protect Your Point

Never stroke with the tip of your brush. Watercolor paper is abrasive, and stroking with the tip will ruin the brush's point.

### Basic Stroke With Your Little Finger Against the Paper

Depending on the stroke, you'll rest the underside of your hand, your knuckle or the tip of your little finger on the paper. This helps to control the brush but also assures that you won't lift it.

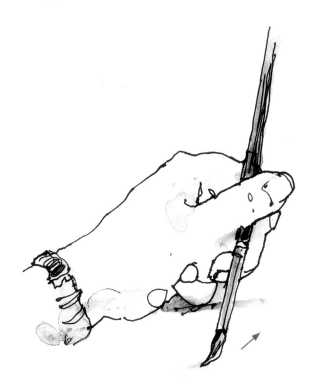

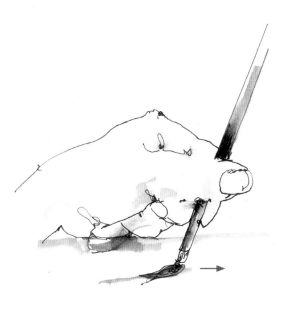

### To Begin a Stroke Away From Your Body

Start by pointing the tip of the brush handle in the direction of the stroke, with the base and knuckle of the hand on the paper.

### To Complete the Stroke

As the hand swivels down, the brush handle tips more toward the direction of the stroke and the hairs become flattened.

## Tapered Stroke

When I need to paint a tapered, feather shape as in painting a palm leaf, I use this stroke. Rest the base of your hand on the paper. Press the brush to the paper in a nearly vertical position.

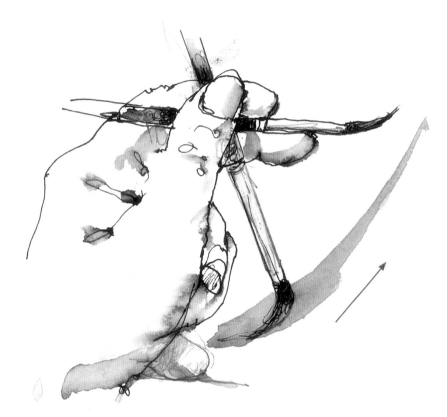

### Lift the Brush

Don't move the base of your hand from the paper, but swivel the brush with your fingers, lifting the brush and narrowing the stroke until the brush leaves the paper.

### Practice the Stroke

Point the brush tip, pressing the hairs to about halfway down toward the ferrule. Without lifting the brush from the paper, relieve the pressure for a thinner stroke, then repeat.

### Avoid Dabbing

Never lift and dab with the tip of a sable brush. This ruins the tip and contributes to spotty paintings.

# Rolling Strokes

I often use this motion while pressing the brush.

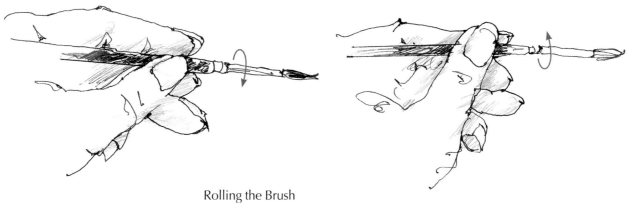

## Rolling the Brush

Hold the brush near the ferrule. Roll the brush between your thumb and index finger.

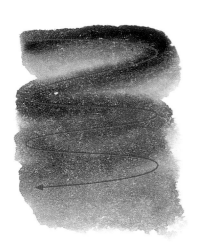

## Connected Rolling Strokes

Here, I've rolled the brush but have connected my strokes.

## Rolling H Stroke

I also paint with a rolling stroke that roughly resembles an *H*. I use this stroke when I need to make a very dark dark.

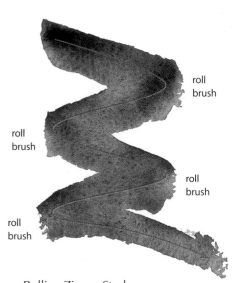

roll brush

roll brush

roll brush

roll brush

## Rolling Zigzag Stroke

Rolling enabled me to make this zigzag stroke without lifting my brush.

# Value

Before using color, you need to understand that all paintings have a value range. A full range extends from white paper through a series of middle values and ends with black, the darkest dark. (In the United Kingdom, the term *tonal* is used in place of *value*.)

Before you try following my watercolor demonstrations, you need to understand the values you'll be using.

To create a value scale, you'll need a no. 4 or no. 6 round that points well when wet, Payne's Gray or Ivory Black (straight from the tube), and smooth, cold-pressed paper. Drawing paper can also work, but avoid Arches block for this particular project because it contains a lot of sizing and you might get a dry-brush, skipping effect when you apply paint for your darker blocks.

## Paint Your Own Value (Tonal) Scale

I've numbered my blocks, starting with 6 on the left and ending with 1 on the right. In painting, the lower numbers indicate darker values while higher numbers indicate lighter values.

Draw six 1" × 1" (2.5cm × 2.5cm) squares in a row. Mix Payne's Gray or Ivory Black with just enough water to let the brush move smoothly. For the darkest square (1), mix 90–95 percent pigment with 5–10 percent water on the mixing area of your palette. You'll need to experiment. Make

a rather thick puddle about 1½" (4cm) in diameter for the darkest value. You'll be adding small amounts of water to the puddle, but you shouldn't need to add more dark paint. Once you've painted a good really dark block, add a little bit of water to the puddle and paint the second block (2). It should appear slightly lighter. In very small increments, add water to the puddle until you can create a range of values up to number 5. I needed several tries to make a good value range, so please don't get discouraged.

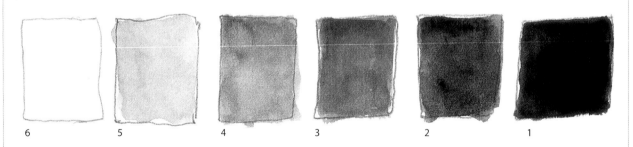

6          5          4          3          2          1

# Color Mixing

Your drawing board and paper should be at about a 45-degree angle. Start with fresh paint and just a bit of water to keep a very dark puddle. There should be only enough water in the mix to avoid a dry-brush effect.

*You must work quickly.* Draw the tip of your damp, rinsed brush along an edge of the wet color you wish to release. The brush should be pressed to the paper about halfway between the tip and ferrule.

## Puddle Color

Many painters rely on what I call "puddle color": the washes that accumulate in the mixing area of their palettes. These colors are generally overmixed, with no trace of the original hues that made the mixture. This may be fine for some watercolor approaches, but I've only seen tired and repetitive painting when my students use puddle color for their middle and dark values.

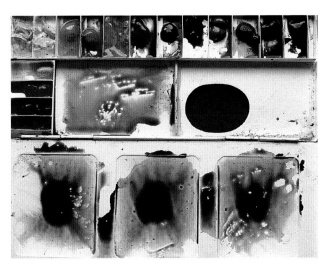

### Stagnant Puddle Color

Watercolor seems to lose heart when it's overmixed. This photo shows how stagnant such mixtures can become. There are no signs of the original colors that made up the mix. It's totally homogenized.

### Mixing Lighter Values

Mix Cadmium Yellow Light or Yellow Ochre or Raw Sienna (try all three of these yellows eventually, one at a time) with a little water in the left side of the palette's mixing area. In the center section of the palette, mix Cadmium Red Light with a little water. Mix Cerulean Blue with a little water in the right section. Always "work-out" the Cerulean Blue with your brush. Adding Cerulean Blue to a light-value mixture takes a little practice because it's granular and should never be added directly. With a clean, damp brush, add a bit of diluted Cerulean Blue to the outside of the red-yellow mix, not the middle. Notice that I placed the yellow on the left side of the mix and the red in the center. Cadmium Yellow Light is stronger in intensity than Cadmium Red Light. If you put the yellow in the middle, you'll get a green tinge to your mix. Notice that the red-yellow mix and the separate Cerulean Blue mix aren't really puddles. The mixes are just wet enough to brush smoothly and still have color identity.

### My Favorite Lights

My favorite combination for lighter warm and cool mixtures is Carmine Red, Cerulean Blue or Cobalt Blue, and Yellow Ochre. Cadmium Red is the easiest to use in medium skin tones.

# Mixing Ratios

**1 Establish the Amounts of Red and Yellow**
Cadmium Red Light is the largest component of the mixture. Because Cadmium Yellow Light is so much more intense than Yellow Ochre, you can use less of it in relation to the red.

**2 Mix the Reds and Yellows**
Using a rinsed, damp brush, draw the red down to thin it. After another rinse, use the the damp brush to bring the yellows down to touch the lightened red. You'll need to work quickly; this process won't work if the yellows are drying. I've placed a dot of Cerulean Blue in the illustration to show the amount of blue I'd use in relation to the red; it's about the same amount as the Raw Ochre. Place the blue away from the yellow. If you mix them before they mingle with the red, you will get a green tinge.

**3 Pull In the Blue**
While the red-yellow mix is still damp, draw the Cerulean Blue into it using a clean brush. The final ratio is about six parts Cadmium Red Light, two parts Yellow Ochre and one part Cadmium Yellow Light. This is a good color mixture for light-value skin tones.

# Adding Darker Color

Painting with dark colors is a lot simpler than dealing with light values. I use only a few colors in my darks. I've been painting so long that I don't consciously think of what color I'm using. I choose colors more for their inherent value as they come from the tube rather than for their hue or temperature. I may use Cadmium Yellow Light or Cerulean Blue (my lightest blue) in middle values, but would use neither for my darker values; their inherent values are too light. I'd always choose my darkest yellow, Raw Sienna, for darker values. Raw Umber is an even darker yellow, but it's so opaque, I rarely use it. I use Cobalt Blue for medium darks and then Ultramarine Blue for my darkest complexions. I like Ultramarine Violet, but it can be overbearing. The different violets are good for certain colors in flower painting but be careful that they don't dominate your color mixtures. Carmine Red and Alizarin Crimson are transparent and brilliant, which makes them good mixers with blue and yellow. I use Burnt Sienna for my darkest red. I've tried Carmine Red in painting very dark complexions but the Burnt Sienna seems to work best for me.

Before copying what you see, always ask: Does this work in my painting? When you see a dark value in the hair or skin tone at the border of a face, think twice before you paint them as dark as they seem. Is the dark going to make a receding part of the face come forward?

Darks come forward. Darks in your painting will be the most apparent part. Never add darks at the end of the painting. Darks must be used as you paint, never added later.

Darks are best incorporated wet-in-wet rather than wet-on-dry. As an area begins to dry, check its value. If it looks like it is going to dry too light, darken the area. If you are using the skin tones from this demonstration, add Burnt Sienna or Burnt Umber to darken the value. Adding Cobalt Blue or Ultramarine Blue will make any dark look darker, but adding it to skin tones can make it too dark.

## Mixing Darker Values

Ultramarine Blue and Burnt Sienna combine to make a good dark. It includes both warm and cool colors, and it isn't an overmixed puddle. You should be able to see traces of both pigments when you make your wash.

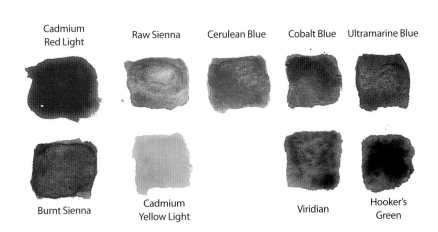

| Cadmium Red Light | Raw Sienna | Cerulean Blue | Cobalt Blue | Ultramarine Blue |
|---|---|---|---|---|

| Burnt Sienna | Cadmium Yellow Light | | Viridian | Hooker's Green |
|---|---|---|---|---|

## Hues for Skin Tones

The top row includes colors I normally use for middle and darker skin tones. The bottom row includes colors I sometimes use.

# Experiment With Different Pigments

I've made a series of swatches to show different mixtures. It's important to experiment with different pigments to learn how they mix. I've used a damp brush to keep the values light, allowing the still-wet pigments to mix together with a minimum of brushwork.

I've noted the colors I've used so you can see the effects of mixing different hues. Cadmium Yellow Light seems to have a "fresher" feel than some other yellows. It is a very intense color and can dominate a mixture, so it must be used in moderation. I'd leave it out altogether but it does work nicely (in moderation) for fairer complexions.

After you've tried Cadmium Yellow Light, try substituting Yellow Ochre, and then Raw Sienna. Though Yellow Ochre and Raw Sienna seem very similar to one another, some students find Raw Sienna to be more transparent. Experiment to see which of these yellows works best for you.

Cobalt Blue is darker in value and mixes well with Raw Sienna to produce a darker mixture.

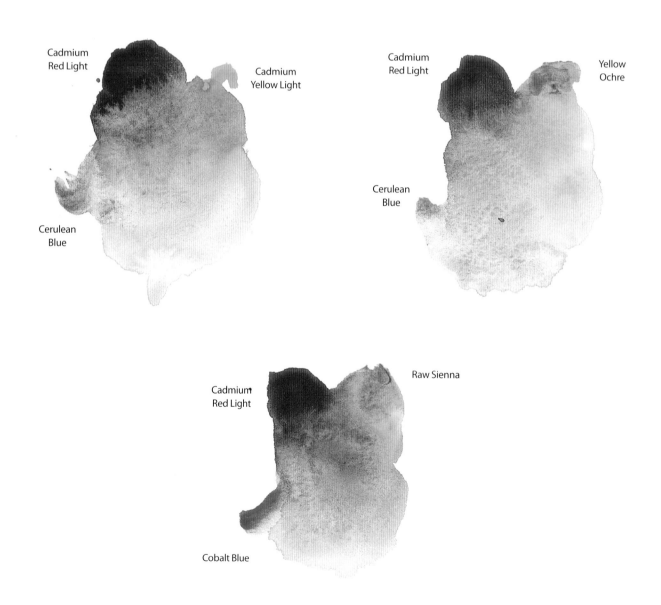

# Tips for Successful Mixing

As it dries, watercolor changes in value, color and intensity. The amount of change depends on the ratio of pigment to water—in your paint, brush and paper.

Use a zigzag stroke as you connect colors, keeping your brush on the paper.

- Don't go back into a damp wash for corrections.
- Let the paint work itself as much as possible.
- For a moment, delete "water" from your idea of watercolor. Think only of *color*: paint just as it comes from the tube. Water is only the medium that makes the color move across the paper. It is an important player, but its role should be minor.

The biggest danger is having too much water in your brush as you lighten a wash.

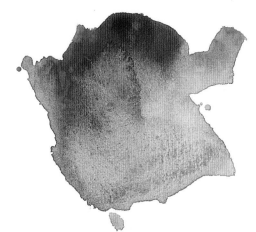

### Too Much Water
Here, there was too much water in the brush and not enough paint. The red and ochre are fine, but my brush was too wet as I tried to mix them.

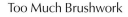

### Too Much Brushwork
The natural color mix was destroyed by too much meddling brushwork. I took a wet brush into a light-value wash and made a mess.

### A Good Mixture
The color here is good, not overworked or ruined with too much water. The pigments mingled together on their own. (When you actually create a color combination, you won't separate the colors to such a degree.)

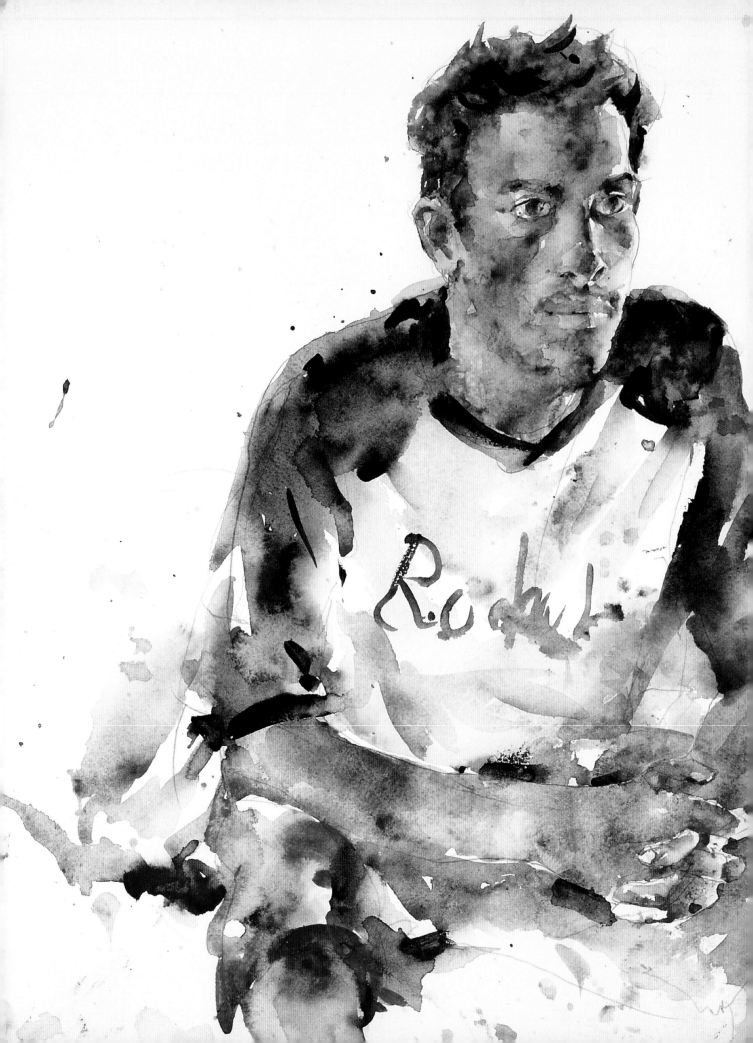

# FIGURES

Cortez
Tuesday ~ painting
with Bobb —
in flt during
driving rain!

**Cortez—Trinidad**

# Heads and Faces

Here I've used a Uni-ball micro pen to draw four head shapes, starting with (a) as a side view and ending with (d) as the front view. (These are generic. The shapes and measurements should be thought of only as a generalized basis for drawing a head.) Then I've added guidelines with a 9mm HB mechanical pencil, showing how I would build a face upon the generic heads.

Each basic head drawn with a pen line is a starting reference for my pencil, which finds new shapes that will help the basic head look like it belongs to a real person.

The angle of the neck changes as the head turns toward you. The front and back of the neck are never parallel. Pay attention to these changes as the head turns. The angle of the back of the neck can be as much as 50 degrees different from the angle of the back of the head in the side view, depending on the pose and the model.

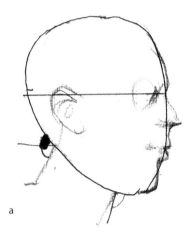

a

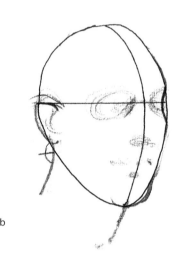

b

## Different Views

**a.** In the side view, the head is generally as wide as it is high. I've placed the eye line at a bit more than a third from the top of the head. Remember, this is a generic head, and many heads won't be as wide or the eye line might be higher or lower. The forehead needs to go out a bit. I've added a nose and extended the lower part of the face to show the dental curve (tooth cylinder), and an angular shape showing the point of the chin.

**b.** As the head begins to turn toward you, it becomes more of an egg shape. The eye line remains a straight line. I've added a centerline that follows the curvature of the face. The centerline starts at the top of the head and travels between the eyes to the center of the mouth and then to the chin. There is a dent next to the left eye showing the underplane of the brow.

**c.** As the head turns more toward you. The centerline is not as curved.

**d.** In the front view, the centerline and eye line are at right angles.

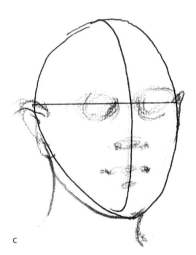

c

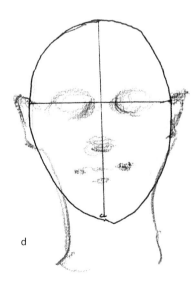

d

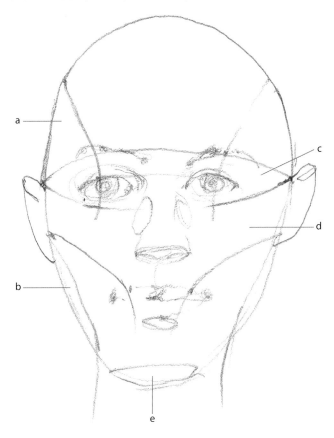

## The Planes of the Face

Concentrate on the places where the different planes of the face meet.

**a.** Notice where the side plane of the forehead meets the front plane of the forehead (rounded).

**b.** The side planes of the lower face start at the ear lobe, extend past the cheekbone and down across the sides of the mouth (rounded until they meet the angular cheekbone).

**c.** The under plane of the brow runs between the upper ears, forming the indentation above the nose bridge and the undersides of the upper eye sockets (a series of rounded and angular forms).

**d.** The upper plane of the cheekbone and underside of the eye sockets disappears below the eye sockets and is taken over by the side planes of the nose.

**e.** The underplane of the chin.

This may seem complicated, and you might not see these planes unless you know they're there. When in doubt, sketch your face with your fingertip. I've lightly drawn the side planes of the nose with ovals. Sometimes students overstress the side of the nose with a hard line or shadow. Again, draw your finger down the side of your nose and you'll see a widening of the nose between the nose bridge and the nostril.

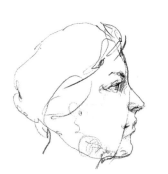 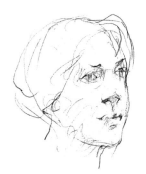 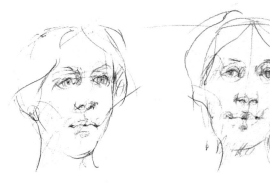

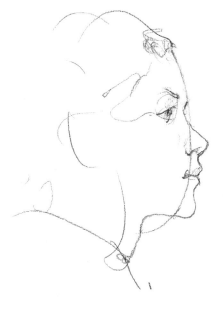

## Turning Generic Heads Into Faces

The faces you see here correspond to the generic heads on the previous page.

Notice the lightening of the eyebrow as it passes across the side plane of the forehead. If you have a model with bushy eyebrows, you won't be aware of this side plane. Notice also the lightening of the values in the lips as they pass over the dental arch. If the model has darker lipstick, you might not be aware of the dental arch.

# Facial Features

Never be too sure that you know the shape of an eyelid or an iris until you've spent some moments studying the eye. Well-drawn, expressive eyes are the most important feature of the face.

Straight on

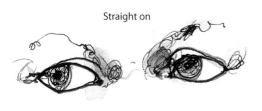

Looking up to the right

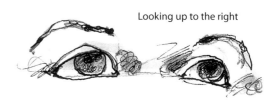

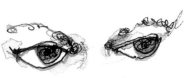

Looking down

## Reminder

Keep the underside of your hand on the paper as you draw; it will help you avoid lifting the pencil from the paper.

## Look Carefully

Here I've drawn three pairs of eyes as seen from different angles. These are generalizations, but I want you to see how different the lid shapes are. Never assume you know how to draw an eye. Before starting the drawing of a face, make some preliminary drawings of the subject's eyes. Draw the eyelids with accurate shapes. This takes concentration. I use a single line, keeping the pencil anchored to the paper as I check for the exact shape. Don't "sketch," or you'll have too many vague lines.

Notice: An eye-length refers to the whole eye, not just the iris. It goes from the inside corner of the eye, passing over and including the iris to the opposite corner. Never think of the iris alone. If you draw or paint the iris alone it will look like a marble. Think of the shape of the lid and the darker shape next to the nose bridge.

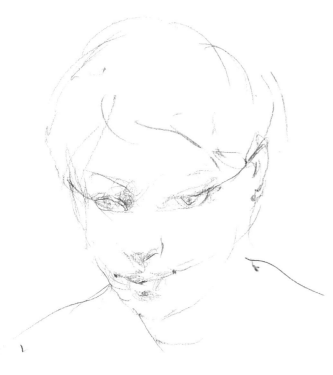

## Viewing Angle Affects the Nose, Too

As the model turns toward you, the nose tip might be very close to the nose bridge. All depends on the tilt of the face in relation to you. If you're looking down at the model, the nose will appear longer and much farther from the nose bridge.

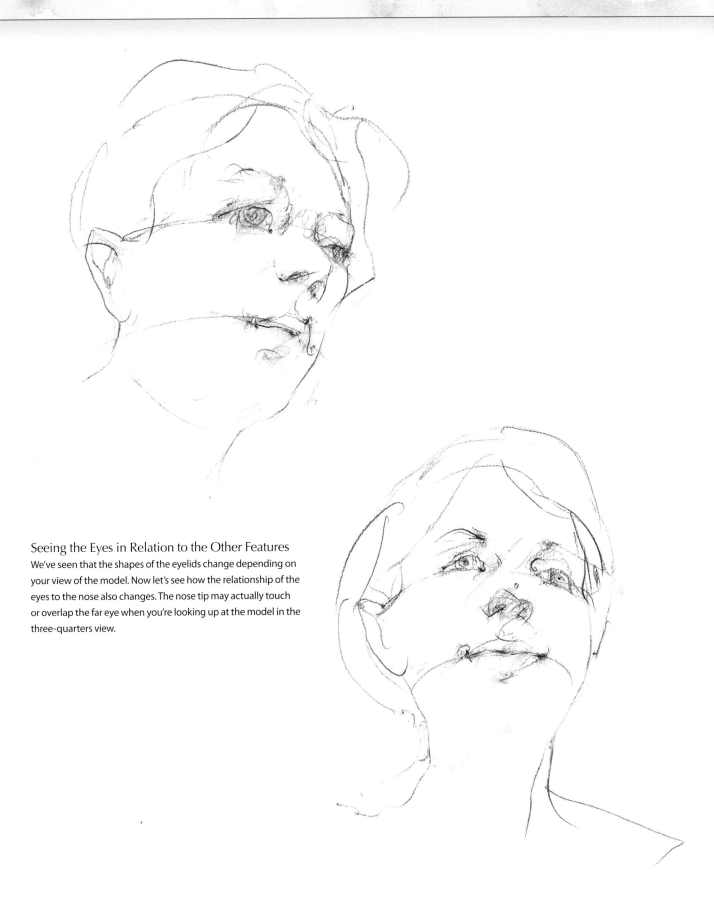

## Seeing the Eyes in Relation to the Other Features

We've seen that the shapes of the eyelids change depending on your view of the model. Now let's see how the relationship of the eyes to the nose also changes. The nose tip may actually touch or overlap the far eye when you're looking up at the model in the three-quarters view.

# Defining Features With Value

Accurately seeing and drawing the shapes of the eyes and other features is necessary, but you must also understand the structure of the face beneath the surface. The structure of the head and the shapes of the features will govern the values and edges you draw and paint.

If this is your first experience looking for values, my examples may be too difficult to manage in watercolor. If so, do the examples in pencil, using your kneaded eraser to soften and lose edges. Creating a range of subtle values from dark to light with hard and soft edges is the key to painting heads and figures in watercolor.

## Eyes

Look back at the generic heads on page 28. I drew ovals (without lids and irises), thinking of the eye as a rounded form that occupies a certain amount of space in the face and lends a sense of bulk and roundness to the head.

Now I want you to build on this. We'll keep in mind the structure and roundness of the head, using darker shapes next to the eyes. Too often, students draw eyelids and irises as if they were floating on a flat surface.

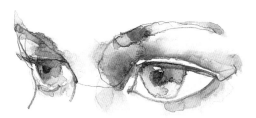

### Notice Eye Details
The iris is not a marble and is no darker than the surrounding darks. The iris often lightens and softens as it meets the white of the eye. The inside corner of the eyelid skips a beat before it gets to the nose bridge. Look for a little white dot between the red dot at the corner of the eye and the nose bridge.

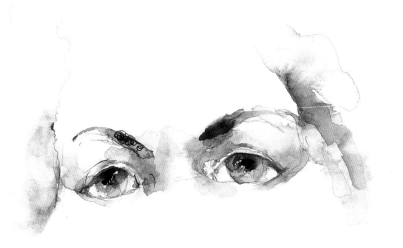

### Notice the Surrounding Structure
Draw the structure surrounding the eyes, stressing the dark shapes inside of the nose bridge.

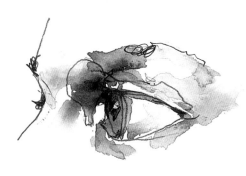

### Notice Similar Values
Combine the iris and the darker shape inside the nose bridge.

## Nose

Unfortunately, the most obvious feature in the nose are the nostrils. The nose's structure is often difficult to see, especially in flat lighting where there are no apparent shadow shapes. This frequently causes students to concentrate on the nostrils, often painting two dark holes.

Find photographs that show light and shadow in the face for practice. Newspaper photos are your best bet. Notice that the shadow shape of the nose and the dental arch shadow shape continues right into the mouth.

a

b

### Create the Nose and Dental Arch

**a.** I've painted the structure of the nose and dental arch with a connected shadow shape. I haven't softened the edges, so you'll see the structure clearly. Notice the shadow's shape. It shows the underplane crossing the front underside of the nose. Then the shadow goes up and over the left wing of the nose. There is a slight lightening. I painted the underplane first, let it dry, and then added the side plane with a slightly lighter tone, let it dry and added the darker tone above. The shadow doesn't follow the actual outside shape of the nose.

**b.** I see this "nose" often, with a dark traveling around the nostril on the shadow side. It is merely a symbol of a nose. The nose tip is always in front of the nostrils. If you paint a dark around the nostril, the nose tip won't project and the nose will look flat.

**c.** I've added the nostrils, making sure not to make them too dark. I've also softened some edges. I wish I hadn't. It looks over finished. I like the simplicity of sketch a.

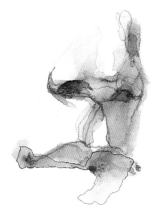

c

# Mouth

Too often, we think of the mouth as a flat, linear shape painted with strokes that run parallel to the mouth's shape. Also, there is a tendency to "color in" an outline of the lips.

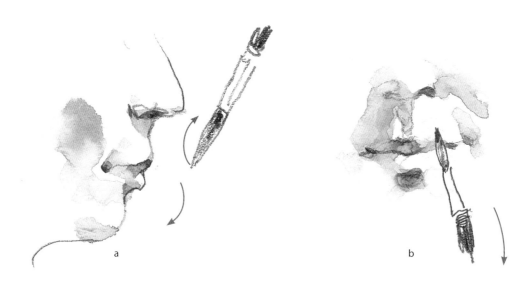

a

b

## Use Parallel and Perpendicular Strokes

In these two examples, I've added drawings of a brush to show that in addition to using parallel strokes, I also paint "across the form" with perpendicular strokes to help connect the lips to the surrounding areas. Use a no. 4 round that points well to pain the mouth with your parallel stroke, then rinse the brush and give it a good shake so that it's only damp.

**a.** Make the corner of the mouth a bit darker, then draw this shape up at a 45-degree angle. Make *only one stroke*. Next, after rinsing and shaking, draw the brush down and across the lower lip into the chin.

**b.** Here, make another single stroke. Start the stroke above the mouth and pass down across both lips. These perpendicular stokes suggest the presence of the rounded dental arch.

# Creating Light-Value Flesh Tones

A good first wash gives you a good color base. Painting your light values with smooth washes takes practice. Light colors are harder to deal with than darker colors. With light-value color, you have more water and less paint, which makes it hard to judge the value. And there's always the temptation to work back into a light wash if it seems too bland, or to blot it if the color seems too strong.

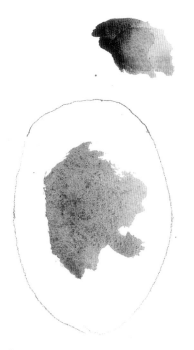

### 1 Draw an Oval and Mix Your Color

Draw an oval. Mix red and yellow on the palette, more red than yellow. Use moist paint and keep the mix rich. Aim at the middle of the oval and start painting away from the center with connecting oval strokes. Use the center part of the brush. As you paint in an oval motion, the brush handle should move at a 45- to 70-degree angle in relation to the paper; the center of the brush should stay anchored on the paper.

### 2 Expand the Oval

Notice that the wash has dried lighter and less vivid than it was when wet. Continue expanding your oval until its about ⅛" (3mm) from the oval outline you drew.

### 3 Add a Blue Strip

Rinse and shake your brush; it should be wet, but not soaking wet. You must work quickly. Paint a strip of Cerulean Blue around the border of your red-yellow mix within the pencil boundary.

# Using Light-Value Flesh Tones

Adjust your light-value washes accordingly with water and pigment. Keep trying. If you find a mixture that strikes you but doesn't match exactly, go ahead and use it in a painting. Use the guidelines below in case it doesn't turn out as planned.

### Too Light
I used too much water with my addition of Cerulean Blue. If your adjoining wash is too watery, it will attack the initial wash. When you are making a light-value wash, shake your brush *after* loading it with the Cerulean Blue or any other light-value color.

### Too Bright
I used a bit too much red-yellow mix in the center for a light-value first wash. However, I do like the richness of color.

### Just Right
This might be the right color and value for first wash for a fair-complected person.

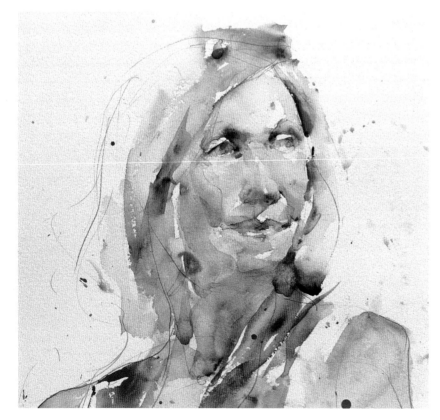

**Lady in Pink**

### Building on a Light Wash for a High-Key Painting
This painting has more unmixed Cerulean Blue than I'd normally use, but this woman resisted subtle color. Strong, unadulterated colors seemed appropriate.

The upper lids were lighter than the whites of the eyes. I painted over the whites with diluted Cerulean Blue before adding a dot of darker Cerulean Blue wet-in-wet for the iris. Some of the color from the darker inner side of the nose (Cobalt Blue, Cadmium Red Light and a touch of Raw Sienna) blended into the inside of the whites of the eyes. For the upper lid, I used Burnt Sienna, but I had to wait until the white of the eye dried before painting the lid. I didn't want any of the red or Burnt Sienna seeping into the white of the eye.

Notice the islands of white paper? With subtle, light skin tones, the dry white paper helped keep a broader value range in an otherwise uniformly high-key portrait.

## Merging Colors

Let the paint do the work. Allow areas of similar value to merge by painting them wet-in-wet; don't worry about keeping a specific color.

### Dark Combination

Raw Sienna

Cadmium Red Light

Cerulean Blue

### Light Combination

Cadmium Red Light

Raw Sienna

Cerulean Blue

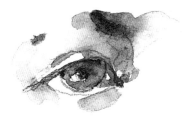

## Painting an Eye

You can see the light and dark versions of the mixtures used to paint this eye. Aside from the noticeable dot of Cadmium Red Light near the inner eye and the areas of Ultramarine Blue and Ultramarine Violet, all the colors in this illustration are variations on that mixture.

Raw` Sienna + Burnt Umber

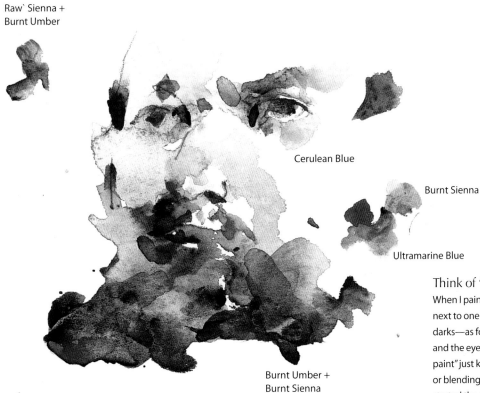

Cerulean Blue

Burnt Sienna

Ultramarine Blue

Burnt Umber + Burnt Sienna

Cadmium Red Light

Ultramarine Violet

Camium Red Light

## Think of "Pieces of Paint"

When I paint, I think of placing different colors next to one another. Sometimes I'll place darks—as for the hair on the left side of the head and the eyebrow—as unblended "pieces of paint" just keeping a pure dark without diluting or blending. Before I added the red to the tip, I started the cheek on the left with more red, a bit of Yellow Ochre or Burnt Sienna. The beard was a breeze: all it took was plenty of paint and some water, just let the dark colors mix themselves without too much help.

# Clothing and Hair

Try to mix and match colors for hair, beards and clothing. I don't have a formula for what colors I use, I just experiment.

For darks, I like to mix a warm color, such as Burnt Sienna or Burnt Umber, with a cool color, such as Ultramarine Blue or Ultramarine Violet. I use Ivory Black only in dark mixes with Ultramarine Blue, Ultramarine Violet, Burnt Sienna or Burnt Umber. *Never* use Ivory Black in mid-value or light-value mixes. For lighter tones , I sometimes use Payne's Gray.

You'll see that colors from the backgrounds sometimes mix into the clothing.

## Apply a First Wash—or Don't

A first wash gives you a good color base and I've always used this approach for younger female models with fresh complexions. I didn't use a first wash for these older male heads as their age and graying skin wanted for more of a flat color.

**Favorite Painters**

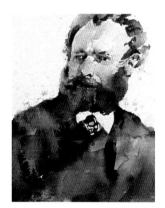

Édouard Manet

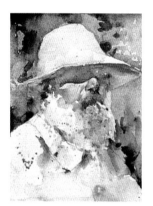

Claude Monet

Pierre Bonnard

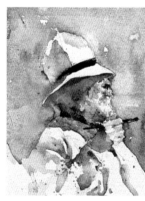

John Singer Sargent

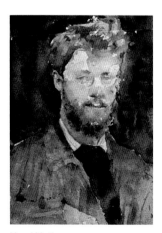

Henri Matisse

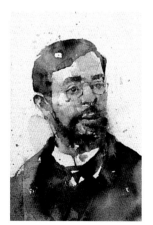

Henri de Toulouse-Lautrec

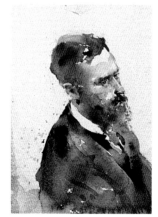

Edouard Vuillard

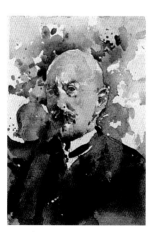

Winslow Homer

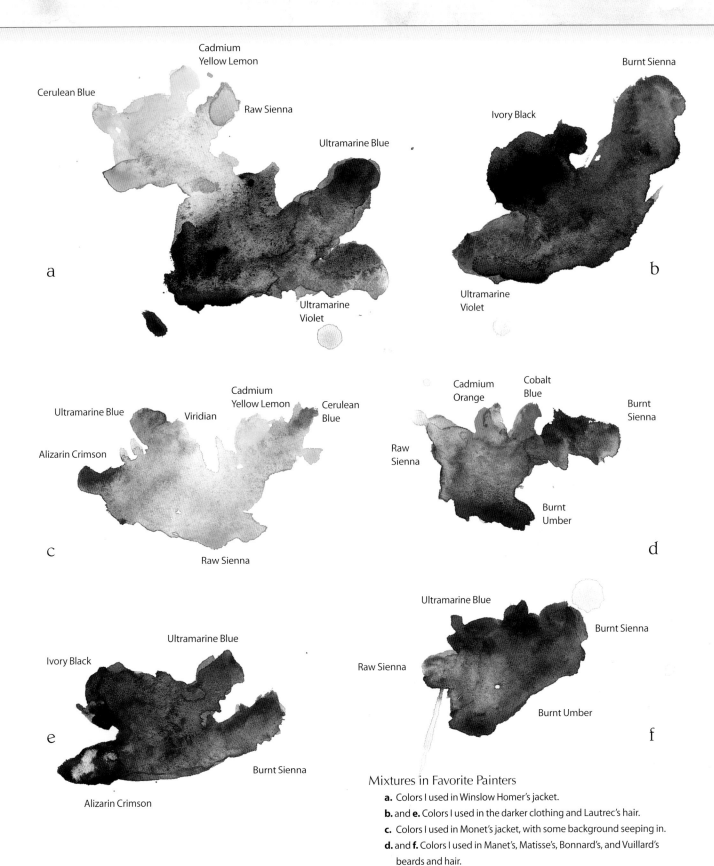

Cerulean Blue

Cadmium Yellow Lemon

Raw Sienna

Ultramarine Blue

Burnt Sienna

Ivory Black

a

Ultramarine Violet

Ultramarine Violet

b

Ultramarine Blue

Cadmium Yellow Lemon

Viridian

Cerulean Blue

Cadmium Orange

Cobalt Blue

Burnt Sienna

Alizarin Crimson

Raw Sienna

Burnt Umber

c

Raw Sienna

d

Ultramarine Blue

Ivory Black

Ultramarine Blue

Burnt Sienna

Raw Sienna

e

Burnt Sienna

Burnt Umber

f

Alizarin Crimson

## Mixtures in Favorite Painters

**a.** Colors I used in Winslow Homer's jacket.

**b.** and **e.** Colors I used in the darker clothing and Lautrec's hair.

**c.** Colors I used in Monet's jacket, with some background seeping in.

**d.** and **f.** Colors I used in Manet's, Matisse's, Bonnard's, and Vuillard's beards and hair.

# Hair and Beards

This model has a ruddy complexion and a white beard. Don't paint the values you see in the photo or you'll have problems. If you literally copy the value contrast of the white beard, it will look as though it has been pasted onto the face.

The hair and beard are *part* of the face, not separate entities. Don't add the hair or beard *after* you paint the face. Many students first paint the skin tones around the hair and beard and then stop. *Don't stop.*

If the hair or beard is darker than the flesh tone, you can paint the skin color right into the hair and beard and then find the darker hairline later when the skin tones are dry. Here, however, the hair and beard are white, so make a transitional tone from skin into the light hair.

I've broken the painting section of this demonstration down into a few steps, but it really should be one effort without stopping. If this seems too daunting for you, try working smaller—that can simplify things. Try painting a head only 2 inches (5cm) high using a no. 4 round.

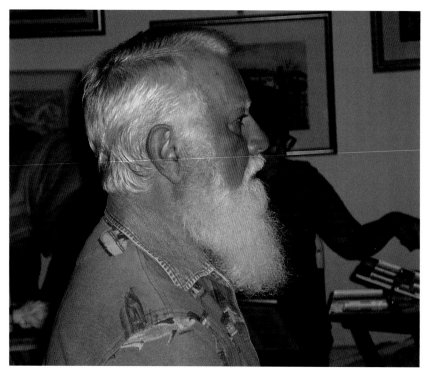

Reference Photo

## Light Complexions

I use the same hues (Cadmium Red Light, Raw Sienna and Yellow Ochre; or their equivalents) for all Caucasian models, even when the model has a richer complexion. To achieve different values, I vary the amount of water in the mixture.

# 1 Draw the Model

Use modified blind contour drawing to draw the model. Keep the line light, and draw very slowly; you'll be looking at the model as you draw, and you don't want to overshoot the mark. Don't lift the pencil when you stop to check angles and distance. You can see where I stopped to check distances because my pencil left a dot; there's one where I made a left angle turn at the sideburn and another where I drew the ear.

You can also see where I doubled back to correct the nose and mustache. It's important not to erase these lines until the end. If you start erasing too soon, you'll probably repeat the mistake. After I finished the contour drawing, I went back, established more correct lines and erased the extra lines where I had doubled back.

Use darker, more definite lines for definite boundaries in the forehead, nose and eye, and lighter, wavier lines for indefinite boundaries, such as where the beard and the hair meet the face. Once you start painting, you'll be worried about so many things all at once, you'll forget about hard and soft edges, so it's good to plant little reminders now.

## Start With Enough Paint

Make sure that you start with plenty of wet paint in your paint wells so you don't have to waste time adding fresh paint to the mixing area.

## Achieving the Right Mix

I don't mix the Cadmium Red Light, Raw Sienna or Yellow Ochre all together in a homogenized mix. I use enough paint on the palette mixing area and enough water, but not too much in my brush, to pick up more Cadmium Red Light or more Yellow Ochre or Cerluean Blue I can change the color mix any way I want using just these three hues.

You really need a hand-held palette to manage this. When I tip the palette toward the vertical, I can see if I have too much water and if the colors run.

I hold my palette near my nose, with water close at hand, as I make adjustments in my three colors. This is exact work; getting the right mix on the palette, transferring it to the paper in just the right place with the right amount of water and then softening the edges when you need to.

41

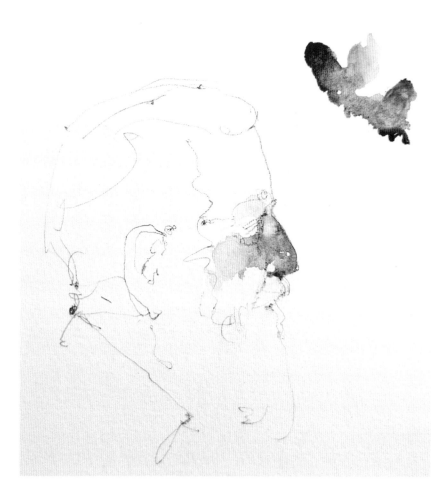

## 2 Start With the Strongest Colors

I always start my portraits with the darker colors in the front of the face: the eyes, nose and mouth. I *never* start with a dark in the cheeks. I want the viewer to look at the face's features, not the darks in other areas.

For the eyes, I didn't start with the blue iris but painted above and around it with Cadmium Red Light and Raw Sienna. I used a bit too much water, so I quickly got more color from my paint supply to paint down and into the nose and back into the cheek. I didn't use any Cerluean Blue until I got to the lower, inner side of nose, where I added Cerulean Blue wet-in-wet at the top of the mustache. I then added the iris with Cerulean Blue and the front of the upper lid with a warmer mix from the palette.

Before going on to the next step, make sure you can manage this step with good shapes. This will aid your transition from the dark colors in front of the face into the lighter, cooler colors by the hair and beard.

### Go Stong With Color

Use stronger colors than you think proper in the beginning and let them dry without fussing. You'll see that all dries calmly.

### Features First

Many students want to put off painting the features, drawing an empty face first or painting around them. Don't do this! You really need the features as reference points for painting the lower parts of the face and figure.

# 3 Add the Lighter Colors

As you move away from the features, continue using the same colors for the skin—Cadmium Red Light, Raw Sienna and Yellow Ochre—but with more water added to lighten the value.

Adding water to the palette mixture is tricky. After adding water, you *must* shake your brush vigorously before painting the lighter colors as you work away from the warmer and darker center. If you shake too vigorously, however, you might not have enough water in your brush. I usually compromise by lightly swiping my brush once across my shirt or apron. I find using a tissue or towel can dry the brush too much.

Start adding more Cerulean Blue to the skin-tone mixture as you approach the hair and beard borders. In some places where the hair's contrast with the skin is strong, you can keep the white of the paper, but that doesn't happen often. In my painting, 80 percent of the boundary between skin and hair is a mingling of Cerulean Blue and the skin mixture.

Paint the neck and ear wet-in-wet with warmer colors; let them mix. The hardest part of this step is not stopping at physical boundaries. If you can master this problem, you will be making a giant step.

As you start defining harder edges within the blur, you will naturally slow down. When you get toward the end, you'll find yourself carefully placing each stroke, stopping to judge the value and resting your brush. Never keep painting just because you have more time; stop painting when you don't know what more to do. Never add darks over dried sections.

I usually prefer my painting before I've "finished" it. To me, the word *finishing* implies adding more and more details, destroying the suggestions and mysteries of the unstated within the painting.

So I don't "finish" my paintings; I "end" them.

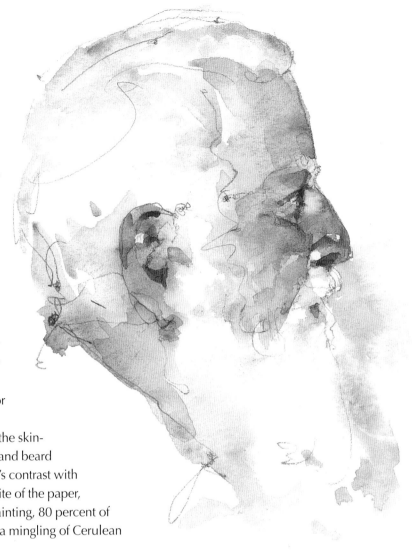

## Value Trumps Color

It's easier to misjudge value than it is color, but value tends to be more important. Color rarely competes with value when it comes to being the key player, unless you have some very intense, vivid colors.

# Finding the "Effect" in Portraits

The "effect" is a single part of the face that you'll make the focal point by using your lightest lights and darker darks next to one another. John Singer Sargent used this technique in many of his portraits. Where to find the effect will vary based on lighting. If the main light comes from above and to the side, the effect will likely be on that side of the forehead (especially if the model is dark haired) and will include the eye.

In this three-quarters view watercolor sketch of the Tom's River model, I had white hair and a ruddy cheek to paint, so the effect moved to the cheek that was out in the light. In the profile painting on page 43, the effect is where the dark, hard edges of the nose meet the white of the paper.

The best way to locate the effect is to squint. When you look at a model with eyes open wide you'll see all of the small light and dark contrasts and end up painting a fragmented composition. But when you squint, you mute the tiny value contrasts so you can focus on the strongest one. In almost all cases, squinting will help you find an effect. (It will always be "out in the light.")

It's all about simplifying. You won't always be able to find a single effect when you're painting a model—in fact, you may find several—but looking for an effect will help you see with an eye that's not so confused with the small stuff. As Andrew Wyeth said, "What you leave out is more important than what you put in."

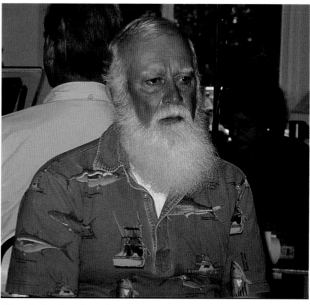

## Check the Eye Level

Be sure you know where the model's face is in relation to you. Don't fall into the trap of assuming that the model's face is at your eye level and facing you! If the model's face is below eye level in a three-quarters view, his closer eye will be slightly lower than the far eye. In a three-quarters view with the model above eye level, the closer eye will be slightly higher than the far eye.

In the photo above, I see that the far corner of the far eye almost touches the left side of the face. Check the shape of the eyes. All eyes are different, but when the model is looking down, the upper lid may be a straighter line and the lower lid more curved. Never draw eyes without including irises. After I've drawn the far eye, I measure an eye-length from the inside corner of the far eye to the inside corner of the closer eye.

After drawing the eyes and irises, use a pencil to find some part of the nose. Try holding the end of your pencil so that the lower part moves freely and can give you an exact vertical, like a carpenter's plumb line. From the inside corner of the far eye, I draw an imaginary line down the model's face to find the left wing of the nose. I see that the right wing of the nose is directly below the inside of the right iris.

### Watch Your Surface Angle

Place your board and paper at a 30-degree angle or less to make mixing colors on your paper easier.

## Concentrate on Technique

Don't worry about exact colors.

### Good Brush Position

Paint with the brush halfway to the ferrule. Hold the handle at a 45-degree angle.

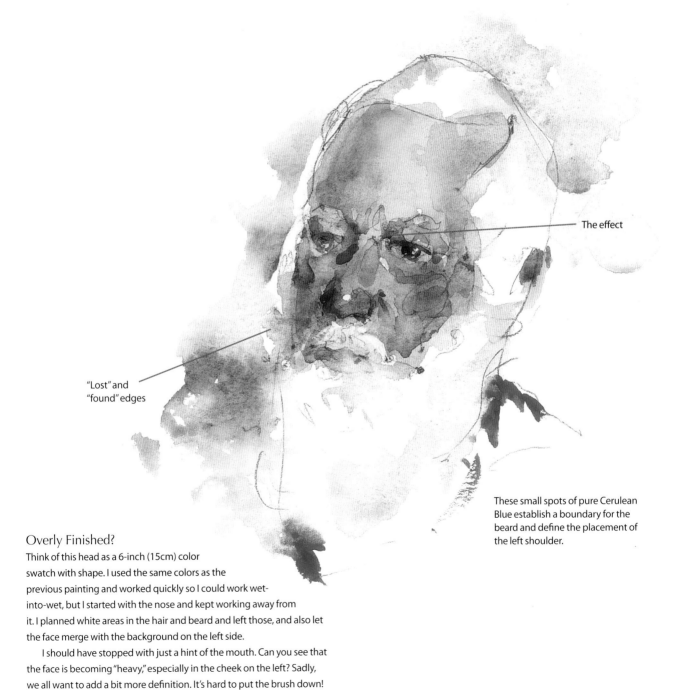

The effect

"Lost" and "found" edges

These small spots of pure Cerulean Blue establish a boundary for the beard and define the placement of the left shoulder.

### Overly Finished?

Think of this head as a 6-inch (15cm) color swatch with shape. I used the same colors as the previous painting and worked quickly so I could work wet-into-wet, but I started with the nose and kept working away from it. I planned white areas in the hair and beard and left those, and also let the face merge with the background on the left side.

I should have stopped with just a hint of the mouth. Can you see that the face is becoming "heavy," especially in the cheek on the left? Sadly, we all want to add a bit more definition. It's hard to put the brush down!

# Lighting

Finding the correct values to create the "effect" can be simplified if you understand how lighting works.

The lightest values should be found in the effect area. Any other light values should be slightly darker; otherwise they may compete with the focal point. Even if there is light showing above the upper lip, as it is here, it shouldn't be as light or apparent as the light in the effect area, which is the forehead here.

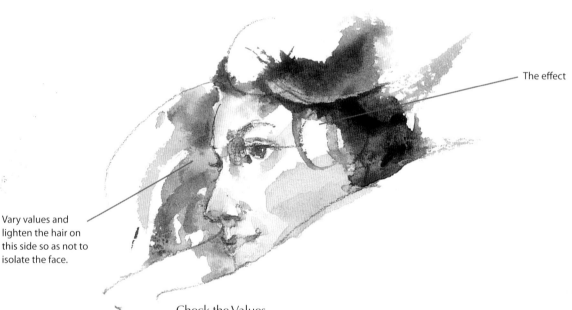

The effect

Vary values and lighten the hair on this side so as not to isolate the face.

## Check the Values

The lower head turns under and is slightly darker than the forehead. With an overhead light source, my sketch assumes a lighter value on the upper cheek. If the cheek were in shadow, there would be a shadow across the nose's bridge and upper nose. Make sure that the hair near the effect is darker than the hair next to the far side of the face. In the hair next to the face, I varied the values so the face doesn't appear isolated.

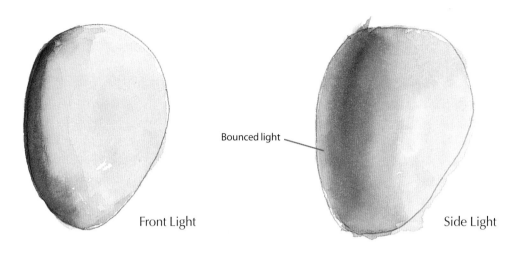

Front Light

Bounced light

Side Light

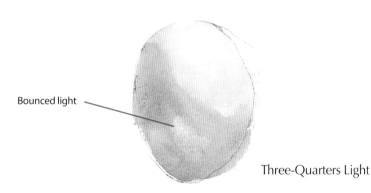

Bounced light

Three-Quarters Light

## Include Bounced Light

Bounced light often affects the values in the face. Bounced light can come from a secondary light source, or from ambient light, or it can be reflected off a lighter surface. Look for this type of light and include it in your portraits; it will add volume to your subject. Remember, however, that no light areas should be lighter than those found in the effect.

## Use Soft and Hard Edges

I aim to have about half the edges soft and half the edges hard in my paintings.

# Painting Dark Complexions

Painting darks in watercolor can be difficult. Are you having trouble keeping your darks from fading into mid-tones when they dry? Here are some possible causes and solutions:

- Are your paints moist enough? You should be able to stick the tip of your brush into a "well" of your paint supply. You should have a brush tip with moist pure color.

- Are you mixing your darks in the mixing area of your palette? If so, perhaps you're using too much water and judging the value of the dark as it appears on the wet palette.

Unless you have 80–90 percent pigment in relation to water on your palette, your dark washes will dry at least two values lighter. Make dark color swatches and let them dry. You'll see how much lighter they are. The more paint and the less water you use in a "wet" area, the truer the value will be.

## Mixing Darks

When mixing darks for skin tones, forget about the color wheel and the exact complementary colors. Burnt Sienna (red) and Ultramarine Blue are "almost" complements and make a good basic mix for a very dark complexion. They are my standbys. In my demonstration on pages 50–51, I've added some other colors, but to start, I'd like you to use just the two "near complements" to make sure you can manage a very dark skin tone.

You need rich darks. It's difficult to mix them on the mixing area of your palette without getting too much water involved. Use 85–90 percent paint and 10–15 percent water. I prefer using paint directly from my paint supply, working it out briefly on the mixing area. Shake your brush vigorously after loading some water from the container to add to the mix on the mixing area.

The colors and added water should not bleed when you tip your palette (a handheld palette is useful). They should remain a moist but contained swatch.

**Burnt Sienna and Ultramarine Blue**
I achieved a dark gray, but it's not a perfect mix. I'd rather you make swatches that are imperfect, letting the paint mix itself. Enjoy the paint as it mixes and dries on its own. Find parts of the mix that please you. Can you see granules of paint on the paper? If you see the granules, you'll know you're not brushing too much and overworking!

**Burnt Sienna and Ultramarine Blue With Less Water**
Here I used less water. When you mix complements or near complements with little water, your resulting value will be *darker* than the values of each of the two colors you used. To start, use only *two* complements or near complements when mixing a dark.

**Viridian and Carmine or Alizarin Crimson**
I haven't used these colors for dark complexions, but I have put them to use as darks in flower painting and landscapes.

Experiment with other colors that have darker values as they come from their tubes to see which suit you. The colors you use aren't as important as keeping a rich, dark value.

# Contrast and Value

Study my painting below. Where did I find contrasts? What values did I use? The greatest contrast is along the left side of Mary's right shoulder and in the blue strip of cast shadow on the wall that intersects her left sleeve. Lesser contrasts are seen in the dress and grass. Do you see where the dress ties in with the grass below Mary's right elbow? Remember local value. The building in my painting is an off white. It's probably warmer and slightly darker than I've painted it. As an example I'd leave an adobe wall white and add the pink or tan siding color later, *after* I painted the shadow or cast shadows.

## Achieving Depth

It's true that cool colors retreat and warmer colors come forward, but the effect is very subtle. A more effective way of achieving depth in your paintings is by controlling the relative lightness and darkness of your values. Always remember that darker values come forward (in this case, the cast shadows near Mary's head). Lighter values retreat.

## Plan Your Highlights

Painting dark complexions takes some planning in the drawing stage. Mark your highlights and place them where you want bits of dry white paper, which act as your "barrier." I mark these with little ovals in my drawing. There's so much to think about in the process of painting that it's handy to have drawn reminders. I also do light shadow-shape reminders.

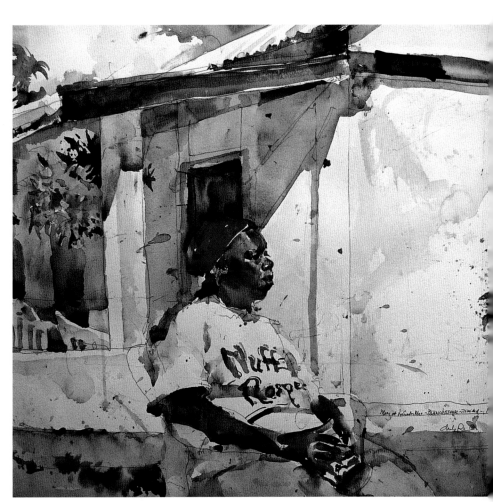

**Mary at Fred's**

## Cast Shadows and Lighting

Generally, the place where the cast shadow meets the light will have a hard edge, be a bit darker and more blue. As the cast shadow retreats into shadow, the values will lighten and usually become warmer due to reflected light from the warmer landscape.

# Painting Mary

Practice painting heads on a small scale (about 3" [8cm] high; anything smaller will make you "tight"). Use a no. 4 or no. 6 round. It must point well. Make sure you can dip your brush tip into your paint supply so that it comes up with a glob of paint. Use the point to find the shape, press to deliver the paint and water, and then paint with the side of the brush (about halfway up to the ferrule) keeping it on the paper as long as possible. (See *Brushwork* on pages 16–19.)

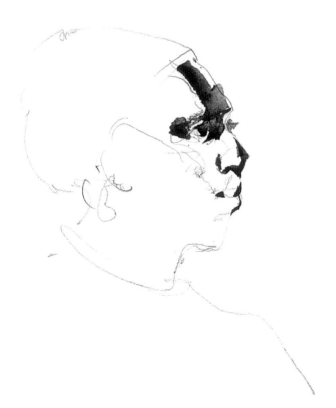

## Use Less Water for Dark Complexions

Painting a dark complexion with too much water can cause flesh to look washed out. After shaking, dip your brush into Burnt Sienna or Burnt Umber and work the pigment out slightly on the mixing area. Then dip into Ultramarine Blue without rinsing.

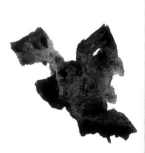

**1 Sketch the Head and Begin Placing Dark Shapes**
Think of painting accurate dark shapes. This sketch illustrates how I'd place "pieces of paint." These "pieces" will be your palette on the paper before you work them out and soften edges. Just use the Burnt Sienna and Ultramarine Blue combination. Color isn't that important; getting enough rich, dark paint is the key since you'll be using these pieces to work out into the midtones. Make a drawing of the head and try to place the shapes as I've done. Connect the forehead dark right down into the side of the nose bridge. I started with the upper lid and iris, then painted over to the nose bridge and up through the forehead. Keep your brush anchored to the paper until you've finished. The dark to the left of the eye, above the eye (Burnt Umber and Burnt Sienna in my sketch), and the nose and mouth shapes can be painted separately.

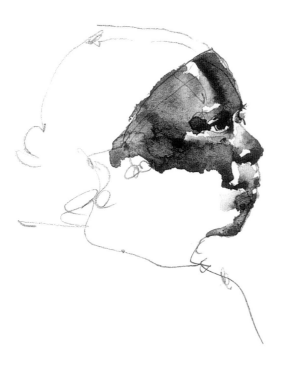

## 2 Continue Painting, Maintaining Darks and Crisp Edges

I like to work on dry white paper when I paint dark complexions. The islands and thin strips of dry paper contain the paint and make it possible to show strong value contrasts that give the face form.

You'll see some softening of edges, but try for a crisp look with hard edges and white paper. I softened the upper nose and nostril using the shapes of dark paint you see in step 1, painting up toward the eye but stopping by the bridge of the nose before the eye form. You want a crisp, dark edge around the eye socket to hold the form.

It's hard to avoid a formless, "mushy" look when using so much paint and water. Squint and notice where you see an apparent separation from a definite dark (eye socket by nose bridge). It's critical that you keep the crisp edge on the dark eye form. The white paper will be the barrier. Paint up to but *not into* a dark you need to protect. Look again at the paint spots at the corner and center of the mouth in step 1. We want to show the roundness of the dental arch.

### Plan Your Edges

Always plan where you'll need to lose an edge. Squinting helps, but you'll often have to ignore what you see and completely lose an edge that only appears partially lost.

## 3 Shadow Wash

I've started the big shadow wash in the cheek. I say "big" because you'll need to have the right amount of paint and water in the brush to obtain a fluid but dark color mix. Start any wash where you want the darkest and richest paint. I want my darks and color at the cheek plane, so I started there and used diagonal zigzag stokes down to where the neck meets the white shirt. Keep the brush on the paper, with the brush's side pressed to the paper about halfway up to the ferrule. In this way, a round brush becomes a flat. If you add colors to the still-wet wash, make sure you go to the color supply, not to the diluted color on your mixing area. Use only a damp brush. If you use a wet brush, you'll destroy the dark wash with a puddle.

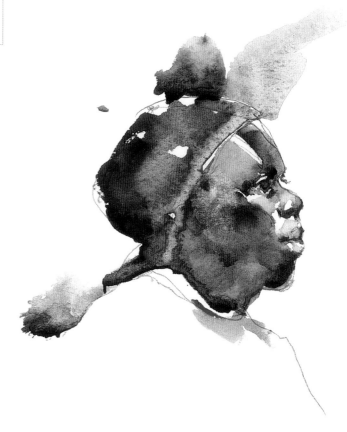

# Plan Your Brush's Destination

When painting a very dark complexion, you need fresh paint with little water. Getting the right pigment-to-water mix is always the key to successful watercolor painting.

Sometimes I use too much paint and not enough water in painting darker skin tones, as I did in Susan's cheek in *Susan 1*.

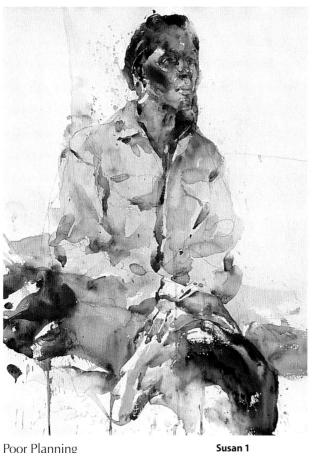

**Susan 1**

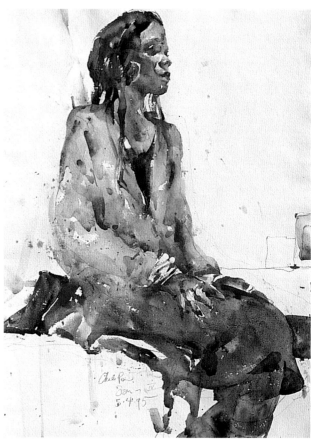

**Susan 2**

### Poor Planning
Avoid lifting the brush and stopping your stroke before reaching a destination. You'll see a dark red, isolated patch in the cheek. I stopped my brush and lifted it.

I should have planned a destination for my stroke. Usually, a cheek or side plane extends from the ear down through the upper part of the cheek, toward the corner of the mouth and into the dark shape below the lower lip.

### Better Planning
Same model, same colors (Burnt Sienna, Raw Sienna, Cobalt Blue and Ultramarine Blue). Better planning allowed me to convey the model's high cheekbones more effectively.

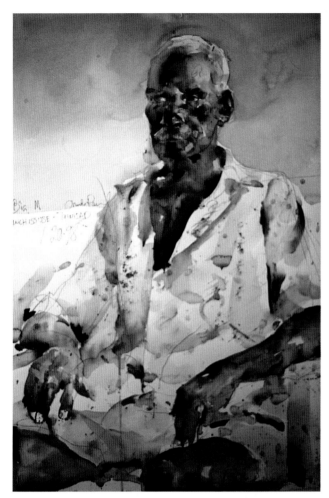

## Plan for Edges and Highlights

When you need to stop a stroke, be sure to soften the edge on any rounded form. When you need to create an abrupt value change, avoid working wet-in-wet. I leave small barriers of dry, white paper around the nostrils, inner eye sockets, eyes and above the mustache on the left side. I also left white paper for the highlights. I mixed many of these colors directly on the paper, so you can see some of the individual hues: Cadmium Red, Burnt Umber, Burnt Sienna, Raw Sienna, Raw Umber, Cerulean Blue, Cobalt Blue, Ultramarine Blue and Viridian.

**Big M**

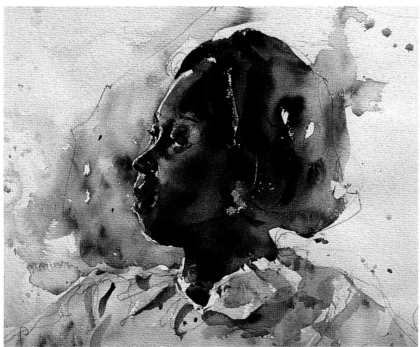

## Paint Dark Shapes First

I paint the eye and the dark shapes around the eye first. Never paint the eyeball and lids as separate entities. Always include the dark around the eye.

Students often paint a definite chin line. Even if you see one, don't. It will cut off the head from the neck and look ugly. I darkened the neck slightly using wet-in-wet.

Faces have different structures under different lighting. Plan your attack and see if you can do the side plane in one stroke.

**Bernice**

# Working With Nude Models

It's hard to find opportunities to paint nudes. Life drawing classes are usually for sketching, with only short poses. For life drawing classes, I recommend that you take a 7mm or 9mm HB mechanical pencil, a pad of drawing paper and a kneaded eraser. You'll also need a support for the pad. I use a piece of foam-core cut to size and secure the paper with clips.

## A Sketch Class Game Plan

Here's a good way to break down the time: five one-minute poses, a break for the model, four five-minute poses, a break, two ten-minute poses, a break, and then two twenty-minute poses with a break in between the two poses.

Most people will be drawing and not attempting to paint. Personally, I don't care for very short poses, but they're a fact of life in drawing classes.

### One-Minute Poses
Use the one-minute poses for warming up. The model will take action poses. Make long lines without lifting the pencil until you need to draw a new part of the figure. Catch the idea of the pose and don't worry about refining.

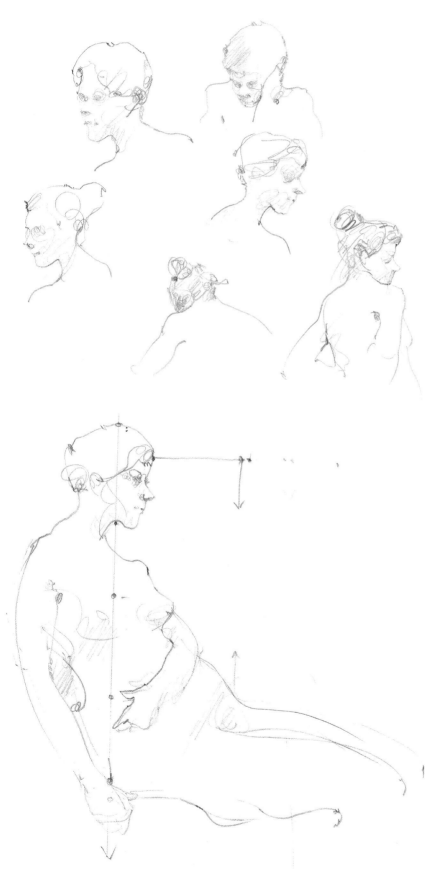

## Five-Minute Poses

This is a good time to concentrate on the angle of the face and head in relation to you, and the model's shoulder lines. Don't try to draw the eyes. I use circular pencil lines to find the eye sockets. Try to catch the contour of the face. I use another circular pencil line to find the underside of the nose. I do a minimum of light pencil strokes to show obvious shadow shapes. These shading lines are made with strokes that are perpendicular to the contour of the model's face and body.

## Observe the Pose Carefully

A common assumption is that the model is sitting upright. An experienced model rarely sits upright—it makes for a boring pose. I estimate where I think the left hip and thigh should be in relation to the right hand. I use my pencil as a "pendulum" placing the lower part of the pencil where the left thigh and hip should be. Looking up at the upper pencil just below my hand, I see that the left hip and thigh are about a head length to the right of the face.

## Ten-Minute Poses

This is a good time to make sure you understand the pose. I hold my pencil vertically to find the right and left hand. Knowing where the right hand is tells me that the model's rear is somewhere under her neck and face. This means that the model's left hip and thigh must be a distance to the right.

# Overworking

I like to ask students what they think is wrong with their paintings before I comment. The reply is often: "It's overworked."

Some possible reasons: Good painters tend to overwork more than beginners. Experienced painters "finish" earlier and see too many things that could be improved on. Classes can present competitive situations and many distractions that can make you lose your concentration. Keep these tips in mind to avoid overworking:

• Once you start losing your concentration, stop.

• Don't go back and make forms more definite.

• Don't add small darks at the end of the painting.

• When you make a stroke that's "off," stop.

I also recommend having a book of John Singer Sargent's watercolors on hand to study each evening before going to sleep. Beyond his amazing skill as an artist, Sargent had lessons to teach us. His message to us: Keep it simple, keep it fresh, don't correct, don't overpaint and let the viewer finish the painting. He made us use our imaginations.

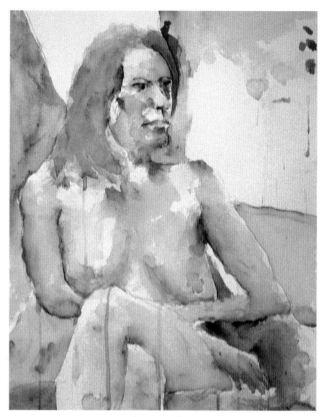

**Don't Wait to Capture the Facial Expression**     **Student Painting**

Here's a great design, with the well-painted figure filling the picture space. I like the subtle background shapes that connect the figure to the picture boundaries. The longer a model poses, the unhappier she will become. Complete three-quarters of the face early, then finish with great care and consideration.

The face was good, but the painter became too involved with the model's unhappy expression. Notice the added darks in the hair on the far side of the face and the hardened edges around the mouth.

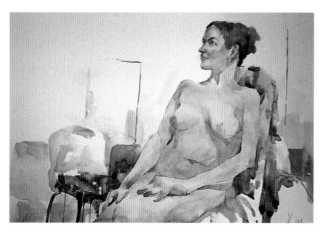

**A Little Too-Fine Tuning**

This picture is beautifully painted and designed. What a good face! The artist saw the shadow shapes in the face and body and painted them with simplicity.

This is a fine painting, but it could be improved. I'd like to see some lost edges. Where would you suggest the painter lose some edges and value contrasts? (Hint: Edges should be firmer and value contrasts greater in areas of importance.)

**Student Painting**

# The Figure in Relation to the Background

Students often concentrate on the figure alone, ignoring the background (see the example below). Painting the figure and letting it dry before going on to adjacent background values and colors is also a common problem (see the example at right). The results are disappointing, which is a shame. These paintings are well composed, with nicely drawn figures. With the appropriate attention to the background, they could have been much better.

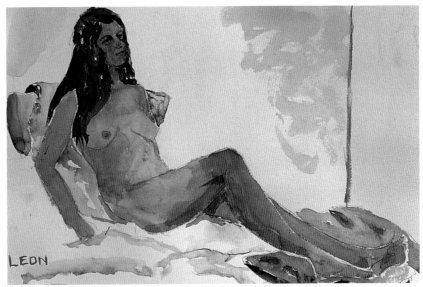

**Student Painting**

### Letting the Figure Dry Before Adding the Background

The figure will probably be overworked. The artist concentrated on the model's tan, molding the figure with small brushstrokes. There are no larger shapes of shadows and cast shadows. There was a strong single light on the model. Figure painting beginners can't seem to "escape the model." It's hard for them to see the figure in terms of shapes of lights and darks. You need darker negative shapes to accurately judge the light values in the figure in the very beginning of the painting. If you are judging the values in the figure against white paper, you might make the figure too dark, or overmodel it.

### Concentrating On Only the Figure

This common mistake can produce a figure that looks cut out and pasted down.

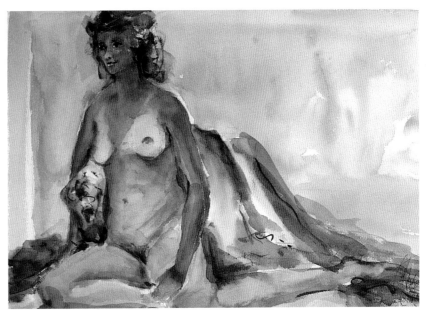

**Student Painting**

# Proportion and Value

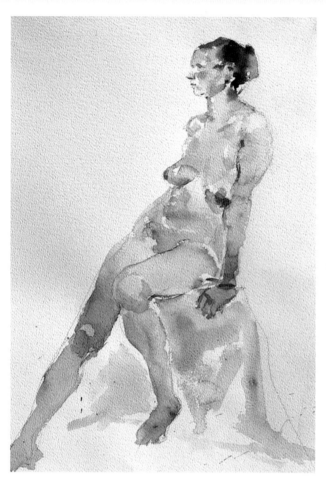

## Good Use of Proportions and Values

This is an excellent study of the figure. Notice how small the head is in relation to the body. It works nicely here, accentuating the grace of the model. The artist has caught the pose perfectly, finding the vertical relationship between the left hand, the ear and head.

The painter also has an excellent sense of values and gets away with using darker negative shapes. I'd like to see this composition using some dark negative shapes.

## Halftones

These are transitional values that act as a bridge between a darker value and a lighter value. Halftones can be very troublesome. Sometimes they look like shadows, but they may be fooling you. Squint to make sure you see actual shadow shapes.

If in doubt, always assume that a midtone is closer in value to your lights. Never make a midtone closer to your shadow.

## Nice Values, But Problematic Proportions in the Face

This is a subtle painting with good shadow and white paper shapes within the figure connecting with the white paper that surrounds it. The painter has concentrated on shapes of nicely defined shadows and cast shadows within the figure with subtle modeling in the halftones on the upper chest and stomach.

The only problem with this painting is that the eyes are a bit close together. If you can't see the far eye's inside corner, make sure you have one eye-length from the inside corner of the closer eye (don't measure from the iris) to the far side of the nose bridge. The far inside corner of the eye will probably be covered by the nose bridge.

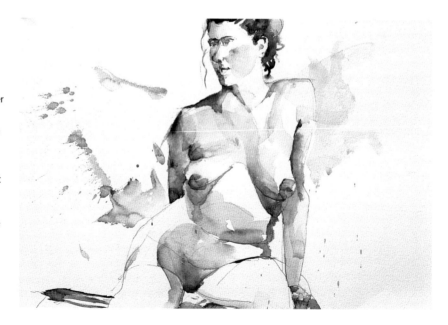

# Composing With Values and Color

I worry about the word *composition* if it suggests only the correct placement of objects and not the placement of light and dark shapes. The strength of a painting depends upon the arrangement of darks and intense color within the picture space. Design your picture with enough darks and color to create a path for the eye.

Turn the book upside down and look at the painting on this page. I want you to ignore the figures, looking only for the dark shapes and how they make a path for the eye to follow through the composition.

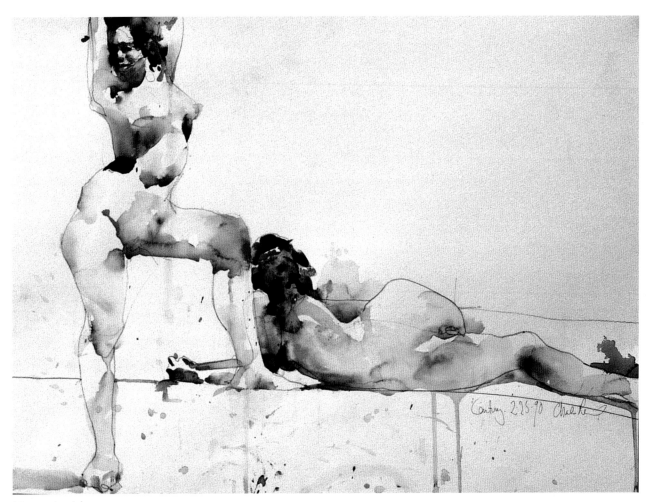

## Happy Accidents

I painted the standing model first, then added the reclining figure. I like overlaps to connect the figures, so I placed the top of the reclining figure's head behind the standing model's left knee. Do you see that the dark knee ties in with the second model's dark hair? I wish I could point this out as careful planning, but it wasn't. Even if you don't plan ahead, sometimes good things can happen anyway.

I think of this kind of painting as a "happening." I couldn't plan the composition since I didn't know what the second pose would be.

# Avoid a Single Center of Interest

I've never understood the common emphasis on the idea of a "center of interest." The fifteenth and sixteenth century masters Jan van Eyck, Piero della Francesca and Pieter Bruegel had great happenings throughout their paintings. Have you ever found a "center of interest" in a Matisse, Gauguin, Vuillard or Bonnard painting?

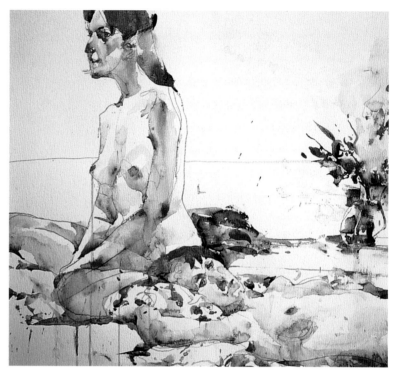

### Move Out From the Center
Instead of creating one center of interest, I like to place several points of interest, often at the edges of my paintings. Think of the "magic triangle." Paint three points of interest. Use an intense color, a darker value or a figure. Your points of interest should be placed away from the center of the painting.

**Redhead With Flowers**

**Century Models No. 10**

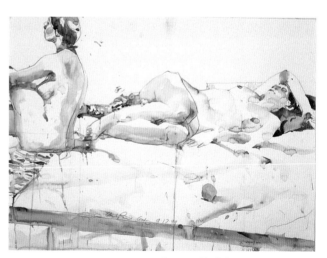

**Century Models No. 2**

### Working With Horizontal Figures
In *Century Models No. 10*, I imagined the vertical shape connecting the model's face to the upper margin. I like to connect the figures to all four of the picture's edges. The magic triangle keeps the viewer's eye traveling through the whole painting instead of getting stuck at one center of interest.

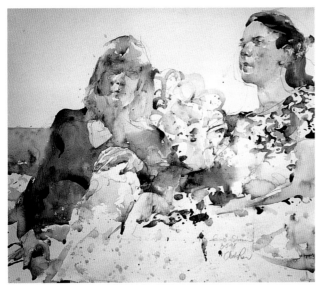

## Use Darks and Details to Lead the Eye
Turn the book upside down so you can see how the darks (and the small, carefully painted hard-edged detail in Susan's blouse) lead your eye through the painting from one margin to the opposite margin.

**Susan and Her Friend**

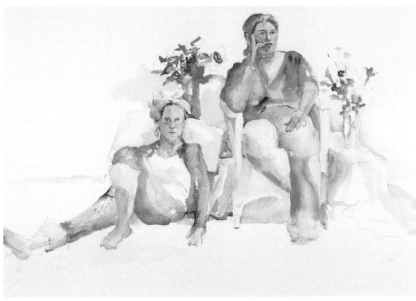

## Composing Small
This is a good painting with a fine sense of the models and their poses. I really get a feeling of the relaxed attitude of the reclining young lady. The problem isn't in the painting, but in its scale. The small figures are floating in a sea of white paper.

**Student Painting**

## Painting Small
No matter the size of your paper, always paint heads 2" (5cm) high. Don't worry about how much of the figure you'll get into the picture. The hands and feet may extend beyond its boundaries. *Never* make legs or arms shorter or smaller. Painting small heads and figures is harder than painting larger ones. Smaller heads take small brushes and you'll find yourself fussing. With a larger head, use a no. 4 round that points well. Paint simple shapes and don't smooth. Some hard edges are good, so don't oversoften. Don't make them fit. This is sort of a zen process. Think of it as a "happening."

## Negative Shapes
A negative shape is usually a darker background shape directly behind a light positive or "subject" shape.

# Finding the Pose

When I draw and paint, I engage a model for a two- to two-and-a-half-hour session. I have her pose for twenty minutes at at time, with a five minute break between each twenty-minute period. This amount of time is good for me and for the model. More time means an overworked painting and a weary model.

## Placement

Don't sketch if you plan to paint over the drawing. Instead, create a single-line contour drawing to help you place the forms accurately. I start with a contour drawing on a separate piece of paper as my warmup. Usually, my first drawing is poor, but it helps me to understand the relationship of the body to the facial features.

Make sure you know which way the model's head is facing. (Students often bring a three-quarters view of the model into a front view.)

Don't leave the model's head and face blank. The features are necessary for finding the exact placement of the shoulder line, arms and torso.

### Use the Pencil as a Plumb Line
Hold the pencil loosely at the eraser. The lower part of the pencil must swing like the pendulum of a clock. Sight along the side of pencil, lining it up with one of the features. Now sight along the lower section of the pencil and see what parts of the figure are directly below the reference feature.

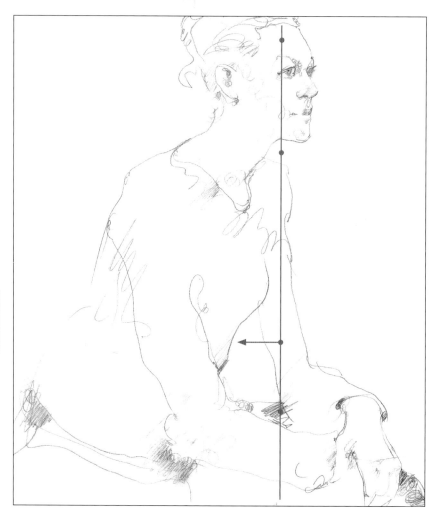

### Getting a Natural Pose

Models usually make good poses if don't you bother them too much.

### Use One Feature to Place Another
Here I used the corner of the eye as my reference feature. The tip of her left shoulder and the inside of her left arm are below the eye.

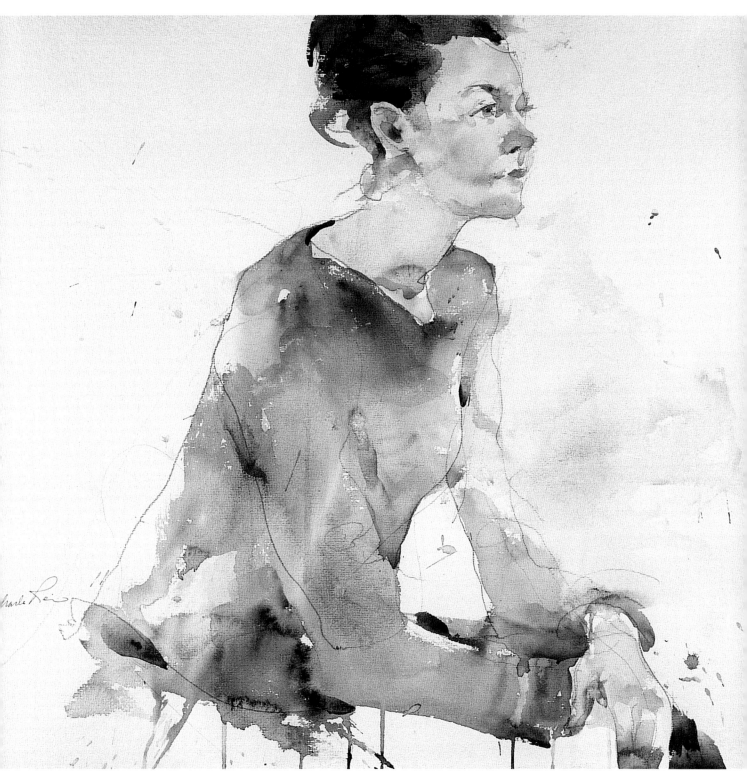

**Jacqueline**

# Proportions

Use your pencil to check your proportions. In the sketch to the right I used the pencil and my thumbnail to find the distance from the top of the head to the model's thigh and knee.

The model's pose and your viewpoint affect the proportions. If the model is leaning forward, as in *Jacqueline*, the upper body will appear shorter in comparison to the head length. Foreshortening also affects proportions. The part of the person that's at eye level will appear larger. In *Red Jacket* (page 65), the model's head is above us. The hands, feet or legs (at the knees) will appear wider. The head, being farther away and above you, will appear smaller.

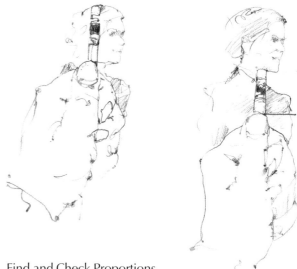

## Find and Check Proportions

Keep your arm straight and elbow locked. Place the top of the pencil at the top of the model's head and your thumbnail on the model's chin. This will be your head-length. You will use this head-length to measure the height of the model and the width of legs and hands.

Now place the top of the pencil under the model's chin. Don't move your thumb on the pencil or relax your arm. In the drawing on the right, my thumbnail is now at the model's upper chest. It would be nice to have a clear reference point, but you'll often have to estimate.

## Planning Proportions

Assume that you'll have three-and-a-half to four head-lengths from the top of the head to the surface the model is sitting on. Always make the body longer in relation to the head-length rather than shorter. Smaller heads in relation to body-length always look better.

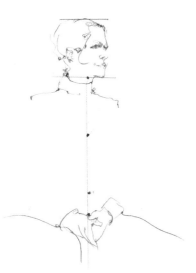

## Using the Head-Length Measurement

This is the way my drawing looks as I measure. I've drawn an accurate head. It needn't be finished. I try to draw a decent face and complete my measuring in the first twenty-minute pose.

I see that my last dot is about half a head-length above the hands. I check the width of the hands between the sleeves and the length of the fingers using my head-length measurement, with my pencil end as my guide. Check the position of the hands in relation to the head using your pencil as a pendulum.

## Use the Head-Length to Foreshorten

Check the widths and sizes of knees, hands and feet. Unfortunately, I didn't include feet here, but I want to make sure I have the knee wide enough. If I don't make the knee wide enough, it won't appear to come forward. I do my head-length measurement, then rotate my wrist and see that her knee and thigh are as wide as the length of her head.

**Red Jacket** ⟶

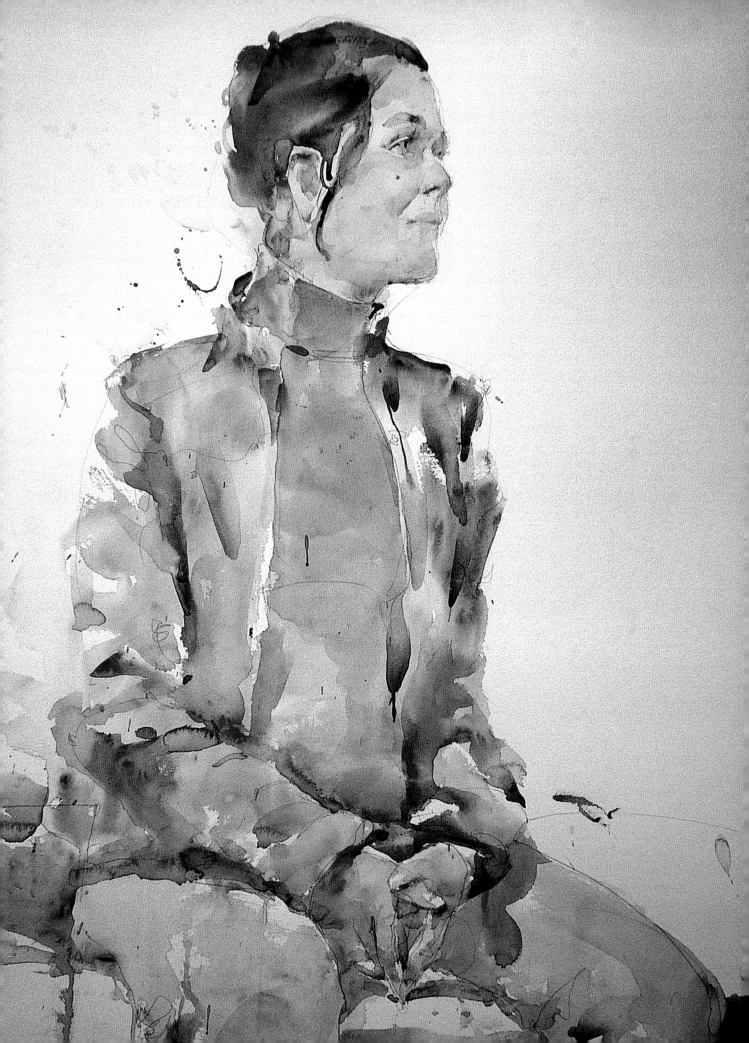

# Finding the Shoulder Line

The shoulder line is the boundary of the inner part of the shoulder or shoulder tip where it intersects with the head. The shoulder lines in relation to the head sets the pose. Looking at the variety of poses below and at right, you'll see that the placement of the shoulder line in relation to the head is very important in catching a pose.

I always carefully draw a reference point within the head to help me find the shoulder line. Sometimes I use the features; other times I use the hair. Then I use my reference point and a pencil to find the placement and proportions for the rest of the figure.

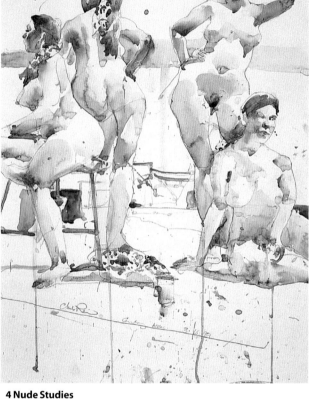

**4 Nude Studies**

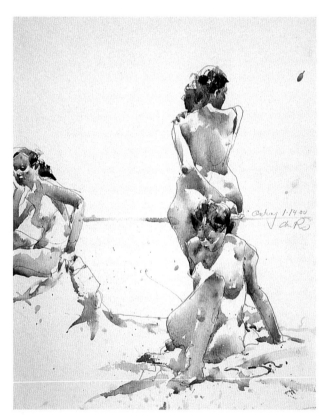

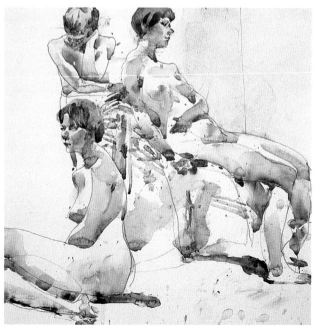

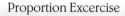

### Proportion Excercise

Use a transparent ruler made to align features or parts of the head with the lower sections of the figure. Make sure the top of the ruler is at right angles with the top of the page. Using the ruler, mark a head-length on the ruler and compare it to the widths of the legs and lower torsos.

Charles Reid Century 3·20·98

# Crossing Boundaries

Jacqueline is one of my favorite models. The pose shown below is a difficult one to paint, but I wanted to show my class that you don't have to copy what you see *exactly* as you see it; you can edit.

The painting's interests are these elements: the face, the hands on one knee (I avoided painting both knees dark—two equal and parallel darks would have been repetitious), the lower legs and the projecting feet. Even within these elements, I let shapes connect and I crossed boundaries.

Don't stop when you have an adjoining shape of similar value even though the adjoining shape has a different identity. Always squint. If it's hard to see a boundary, paint over that boundary regardless of the identity of the adjoining shape.

Never create a form that is completely isolated. Every form should have a bridge to a neighboring form with a lost edge or similar congenial value.

Study the painting of Jacqueline (below) to see where I crossed boundaries between shapes, and where I left a separation. See if you can identify where I used a wet-in-wet technique.

I usually start with the eye out in the light. I first painted the upper lid using Cadmium Red and Raw Sienna, then painted the iris with Cobalt Blue. I shook my brush (to ensure it was just damp and not wet), then led the blue of the iris toward the inner corner of the eye.

I connected all of my shapes under the eye, leaving a bit of dry paper in the lower lid, then up along the bridge of the nose, into her right eye socket and into the forehead.

The cheeks are Cadmium Red and Yellow Ochre with Cerulean Blue added around the lower cheek and under the Cadmium Red mouth. The cheek, mouth and shadows all connect.

The nose is Cadmium Red and Raw Sienna with Cerulean Blue for the cast shadow. I first painted the tip and underside of the nose with Cadmium Red and Raw Sienna. I started my Cerulean Blue stroke above the center of the mouth and painted up to meet the still-wet nose color and let them mix on the paper.

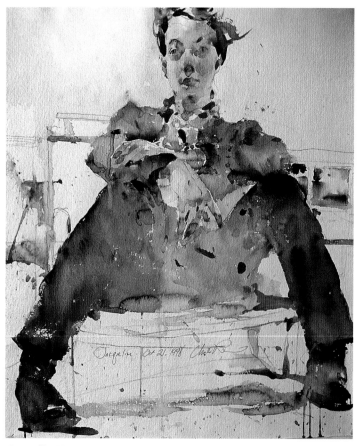

**Jacqueline II**

Notice how I connected the shoes with a cast shadow? Always show a cast shadow painted at the same time as the object that casts it to anchor the object to the surface it's resting on.

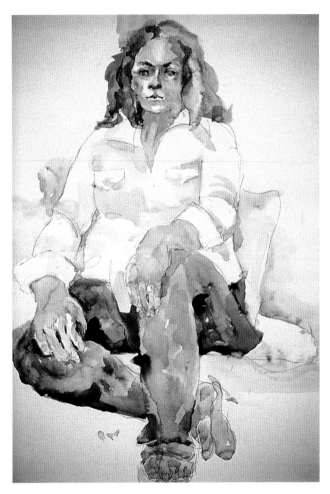

## Student Painting of Seated Model

This is a fine painting. It has many good elements: excellent drawing, no overworking or over-painting and excellent local color. Notice the lighter details in the shirt, the darker overall value in the jeans, and good color and value in the face and hair.

In a classroom setting there will probably be just a white wall behind your model. This artist wisely filled her picture space with the figure and didn't need to worry about a background. (Never start a small figure on a large piece of paper without thinking about what you'll do with all of that empty paper. Small figures are harder to paint than big figures because you'll probably use a little brush and add too much detail. If you do a small figure, make a picture border around it so you can decide early what to do with your background space.)

The only problems are the values in the jeans. The values are too dark in the model's bottom and right thigh. Remember that dark values attract the eye and come forward. We do not want the model's bottom and thigh to come forward.

**Student Painting**

## Corrected Sketch

These jeans are stonewashed. This, along with lighting, makes the darkening of her right knee and advancing lower leg difficult. Instead of looking at these very light tones, try looking at the color/values you see in the model's right thigh and bottom. Here, I reversed the values I actually saw. I used the values from the model's thigh and bottom in her right knee and advancing left leg instead. I also lightened her right lower leg so it disappears behind the advancing left lower leg. Dark values and firmer edges come forward while lighter values and "lost" edges recede.

# Edge Control

Edge control is the ability to soften or lose an edge while retaining an adjacent firm or found edge. The biggest, most common problems in the control of edges occur around a face (or in any other limited section of a painting).

## Softening Edges

In smaller areas, you'll often need to soften an edge to bring two "incompatible" values together, creating a *halftone* or a bridge between the darker value and the lighter value. (By *incompatible*, I mean a light value next to a dark value.)

Softening the edge of a long dark form is difficult. It requires a big brush and a perfect control of the water-to-paint ratio. "Hard-edge" painters use subtle, lighter intermediate values to make their halftones. I tend to lighten dark shadow or darker local color values as they approach a lighter adjacent value.

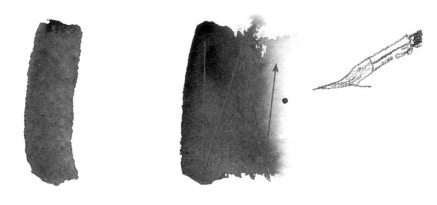

### A Softening Stroke
Paint a vertical stripe. Use plenty of paint and just enough water; too much water can ruin a good soft edge. Immediately rinse and shake the brush twice. With one stroke, pass the tip and underside of the brush along the outside edge of the stripe. Make a zigzag stroke away from the stripe. When you've finished one pass with the zigzag stroke, stop! Let the paint and water finish the work.

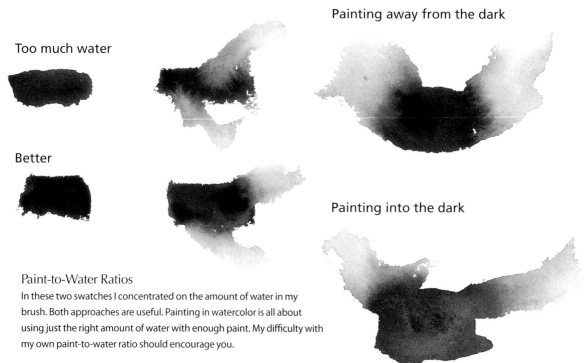

Painting away from the dark

Too much water

Better

Painting into the dark

### Paint-to-Water Ratios
In these two swatches I concentrated on the amount of water in my brush. Both approaches are useful. Painting in watercolor is all about using just the right amount of water with enough paint. My difficulty with my own paint-to-water ratio should encourage you.

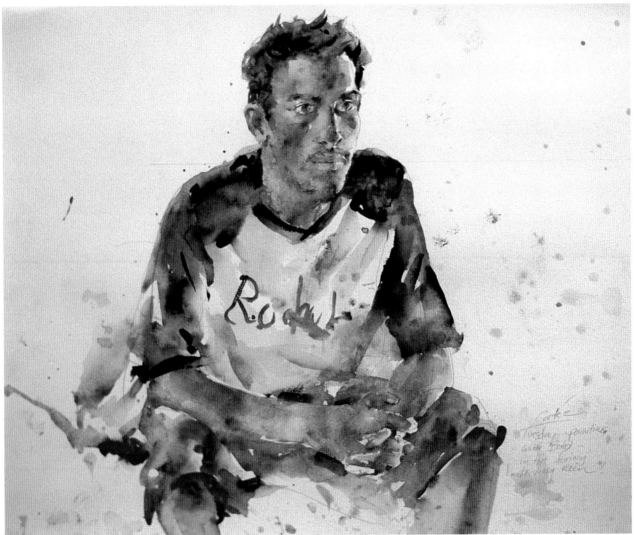

**Cortez—Trinidad**

## Softening

I adjusted the value of the shirt near his waist, softening the strong contrast of the black and white. I wanted the strongest contrast to be up at the advancing shoulder, not down by the lower torso.

This painting was done under a shelter in a driving rain. The texture and many of the lost edges in the painting are thanks to the rain. Under these conditions, you must keep islands of white paper with definite edges. You'll see these islands in the face, shirt, arms and hands. If you don't save islands, your painting will dissolve into a mess.

Plan ahead. With a light pencil line, mark where you want to place the lightest lights. Don't do a preliminary light wash in this situation; start with your mid-darks and darks where they meet the islands. Leave a tiny space to soften the edge between the mid-dark and preserved white paper.

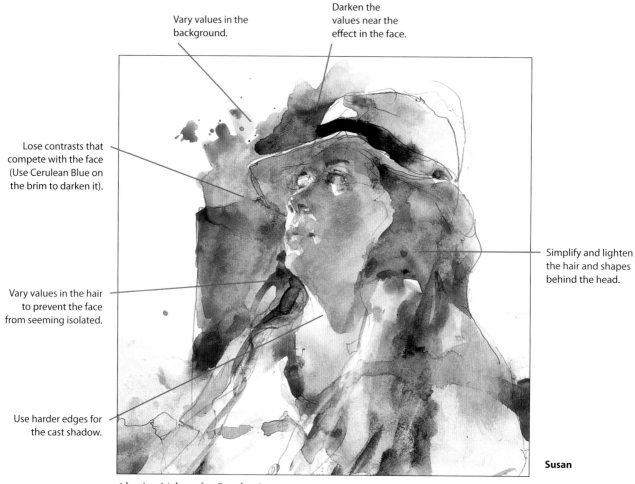

Vary values in the background.

Darken the values near the effect in the face.

Lose contrasts that compete with the face (Use Cerulean Blue on the brim to darken it).

Simplify and lighten the hair and shapes behind the head.

Vary values in the hair to prevent the face from seeming isolated.

Use harder edges for the cast shadow.

**Susan**

## Altering Values for Emphasis

If you had been present when I painted Susan, you would have noticed a definite separation of the front of the hat brim next to the dark wall behind it. At the back of Susan's head you'd have seen very dark hair, a lighter hat brim and a light wall.

When you look at a model, you'll see many parts that call for your attention. Deciding which elements deserve your attention is part of the painting process.

Here, I decided the front of Susan's face had to stand out, so I lost the contrast under the hat brim in front of her face, and lightened and combined values in the hair and underside of the brim into a single shape.

### Creating Emphasis

Always ask yourself: "What do I want to emphasize?" To accentuate one thing something else has to be sacrificed.

# Connect the Dots

Many students generalize shapes into rounded curves because they ignore or don't see minor directional changes. Use dots to help you locate shifts in contour.

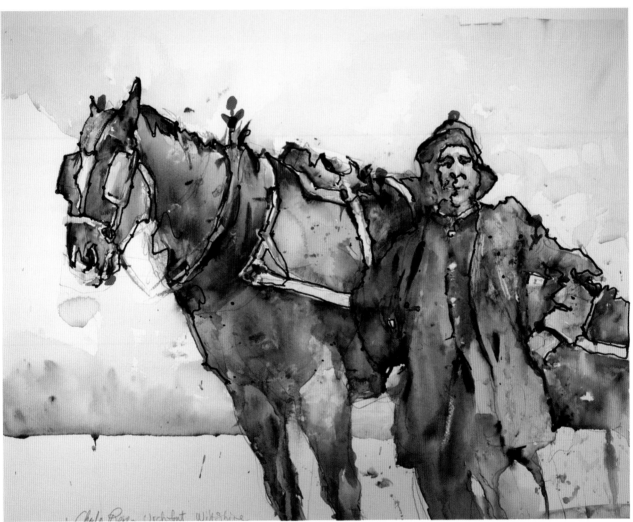

**Will and His Horse—Urchfont, Wiltshire, UK 1937**

### Create a Contour Drawing Using Dots

When working from a reference photo, you can simply lay tissue paper over the image and, using a felt pen, make dots at the various points where you sense shifts in the direction of the shape. Each time a form's contour makes even a minor change, make a dot. Do this within the objects as well to give yourself a guide, as I did with the horse's bridle and blinders. Estimate if you need to. Using your felt tip pen, connect the dots using *straight* lines.

# Painting From a Black-and-White Photograph

The advantages of painting from old black-and-white photos is that the images are simplified into dark and light values, with few or no halftone details. Halftones can be confusing when painting from life or color photos. Sometimes they suggest a dark and sometimes they suggest a light.

All good drawing depends on comparing the correct placement of one shape in relation to other shapes.

Never think of a shape in isolation. It's all about the relationships of shapes, edges and colors.

Sometimes you'd like a bit more information than a black-and-white photo has to offer, but the advantage is that you also won't be confused by the detail in halftones. Simplify and combine different parts of your subject that are in shadow. Simplicity is our goal.

## Low-Country Friends
This reference photo is used in each exercise in this section. I decided to leave out that poor snake, however.

### Study the Photograph
Study the photo, noticing how many darks merge with adjacent darks.

Try not to think of painting a horse and two men. Instead, look for shapes of lights and darks. Look for cast shadows and other shadow shapes. They'll be the foundation of your picture.

Look for definite hard edges. They are easy to see in this photo. Softening edges take practice. If an edge appears definite in the photo, leave it hard in your painting rather than fussing with it.

Look for the lost boundaries between different "objects" in the photo. Notice that you can't see where the underside of the hat ends and the face begins in the center figure. If you can't see a separation between the saddle blanket, saddle and horse, don't imagine a separation. Let the horse's underside, blanket and saddle merge.

Paint the cast shadows on the ground. Apply the paint to dry paper rather than wet-in-wet to achieve hard edges on the boundaries of the cast shadows, but combine the dark parts of the horse's hooves, the man's boot's and his companion's legs. Don't paint the horse's and men's legs separately from the cast shadows.

# Enlarging and Transferring a Photo

Make your reference photo bigger to successfully transfer it to your watercolor paper for painting. Have an 8" × 10" (20cm × 25cm) enlargement made of the reference photo.

Enlarge the photo images, keeping the men and horse in the same relationship to the margins in the reference photo. If you'd like to use my reference photo, make a color photocopy of it. (Color copies have better resolution than regular black-and-white.) Decide on how large a painting you want. I didn't make an exact enlargement, so don't worry.

**1 Draw a Diagonal Line**
Place your ruler diagonally on the lower-left corner and upper-right corner of the photo. Draw a light line, continuing the line beyond the photo several inches. You will use the length of this line to determine the dimensions of your painting.

**2 Draw Horizontal and Vertical Lines**
After outlining the lower-left corner of the photo on the watercolor paper, extend the bottom dimension of the photo several inches (centimeters) with your pencil, estimating the length of the horizontal dimension of your enlargement. Then extend the left dimensions of the photo several inches (centimeters) with your pencil, estimating the length of the vertical enlargement.

**3 Place the Photo**
Make sure that the photo corresponds exactly with the 45-degree angle of the lower corner of the watercolor paper. Place your photo 1½" (4cm) in from the corner of the watercolor paper.

**4 Connect the Lines**
Draw right angle lines from the extended vertical and horizontal lines. When these lines intersect with the diagonal line you drew, you will have the dimensions of your enlargement.

# Low-Country Friends

Make swatches like these before trying to paint the horse. Make sure you can paint a rich dark. Mix your different darks on the paper using whichever colors you choose. Your paints must be wet. Don't fuss with your brush. Get the right amount of paint and enough water so the paint can mix itself. I've used several color combinations. Try them all and see which suits you.

Cadmium Red, Raw Sienna, Cobalt Blue

Viridian, New Gamboge,
Ultramarine Blue

Cerulean Blue, Yellow Ochre,
Carmine Red

Payne's Gray, Raw Umber,
Ultramarine Blue

Burnt Umber, Burnt Sienna, Payne's
Gray, Ultramarine Blue

Payne's Gray, Burnt
Sienna, Ultramarine Blue

Raw Umber, Burnt Sienna,
Ultramarine Blue

Ivory Black, Burnt
Sienna, Ultramarine Blue

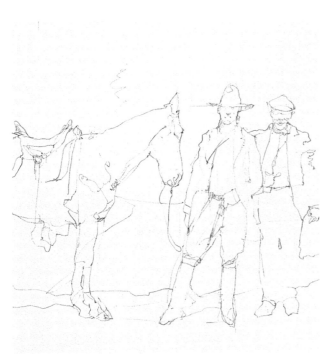

# 1 Sketch the Photograph

Be sure to keep the heel of your hand on the paper. Draw very slowly, keeping the pencil anchored to the paper as well. After drawing the central figure, use him as the guide for drawing the horse's proportions. Draw the legs out into the cast shadows on the ground. Plan where you'll leave your dry, white-paper highlights.

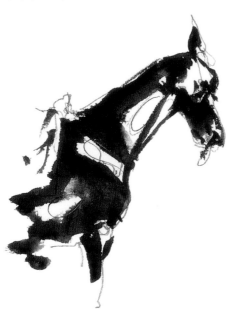

# 2 Paint the Darks

Paint your darks around the planned lights in your drawing. Rinse and shake the brush so it's between damp and almost dry.

# 3 Soften the Edges

Quickly, using single strokes, soften the edges of the dark shapes. Don't use a fussy brush; don't lift and dab. Keep your brush halfway down to the ferrule. Make one pass with your brush to soften. I restated my darkest dark with Payne's Gray, wet-in-wet.

# 4 Paint the Horse

You must paint the horse in one go. I leave bits of dry white paper to create highlights that help describe the form of the horse's chest, upper leg, saddle, bridle and trees. The dry paper highlights stop the wet paint from flowing out of control in places that definitely need to be kept light. Never paint a positive shape (the subject figure) without painting the negative shapes (the adjacent background).

# 5 Paint the Saddle Blanket

Using Viridian and Yellow Ochre, paint the saddle blanket right over where the saddle will be. When you have two objects of similar value, or if the overlapping object is darker, paint the lighter object first. Don't worry about the boundary between them at this point.

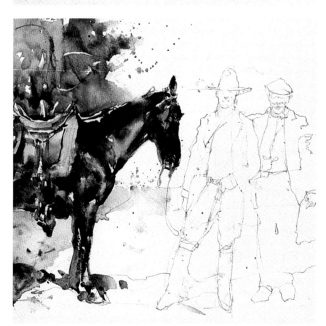

# 6 Paint the Saddle

I let the blanket dry, then painted the saddle with Burnt Sienna, Raw Sienna and Cerulean Blue. I allowed the colors to mix on the paper, leaving highlights of dry white paper. When the colors are dry, paint the dark separation between the front of the saddle and blanket with Burnt Umber.

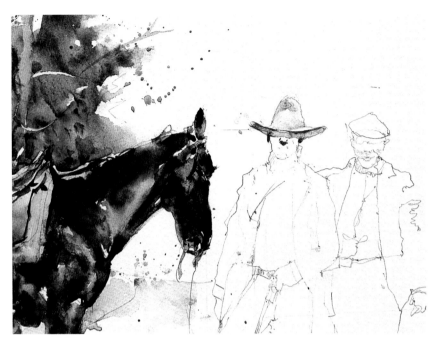

# 7 Start on the Central Figure

The underside of the hat brim and the head are in shadow. Merge the two adjoining shapes into one by creating a lost edge between the two shapes.

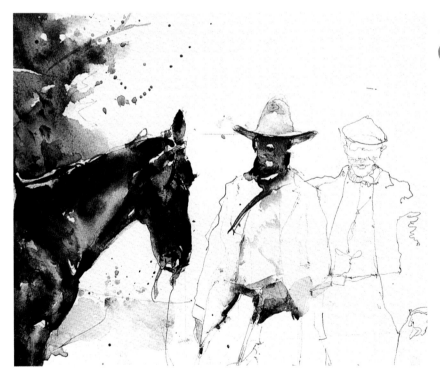

# 8 Paint the Hat and Face

Continue painting into the face (review the skin tone swatch on page 76). I've left white paper for the top of the nose and chin. In the photo, the nose isn't out in the light, but I thought the face would have more form with a lighter nose. You need to use plenty of paint so the underside of the hat brim (Cerulean Blue) and scarf (Viridian, Ultramarine Blue and Mineral Violet) can blend with the face without a watery bleed. Immediately combine the hand with the Ultramarine Blue cast shadow. Always use darker colors *directly* from your damp paint supply wells. Don't mix paint with water in the mixing area. Paint the hat with Cerulean Blue and Raw Sienna.

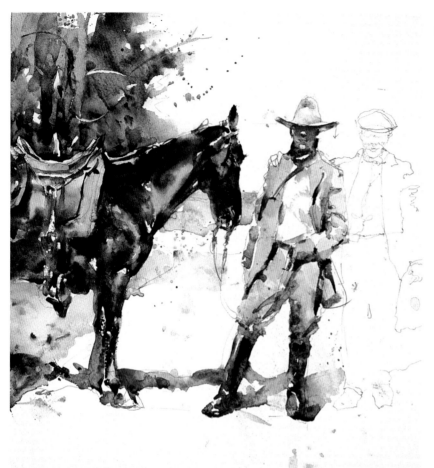

## 9 Add Clothing and Boots

See the variations of the central figure's colors in the swatch and find them in the man's tan suit. Allow the colors to combine and mix on the paper. Think of his suit as a color swatch with a specific shape. I used Cerulean Blue and a bit of Raw Sienna in the shirt.

The boots are Burnt Umber and Cobalt Blue or Ultramarine Blue. I painted wet-in-wet, but left dry white paper for the shine on the boots. Also, leave a bit of white in the top of the left boot to hold the edge. You'll need to do some softening in the boots, but make sure you save white paper highlights.

I painted wet-in-wet in the left leg, then waited for the initial wash in the clothing to dry before adding darker details wet-on-dry.

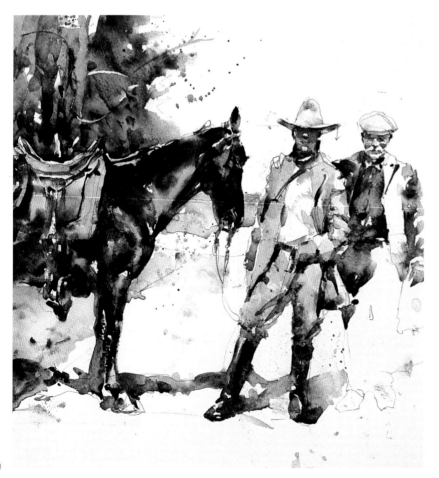

## 10 Paint the Right Figure

Be *very* careful to paint a descriptive shadow shape under the hat of the figure at the far right. Keep the light parts of the face dry white paper. Keep the tip of your little finger on the paper to steady your hand. You should be able to see the tip of the brush. The brush handle will be pointed up at about a 45-degree angle in relation to the paper (see *Brushwork*, page 16). I like to work in sections when I'm painting darks in a fairly large section, as in the man's suit. I find places to stop where there is a definite light boundary. Never stop painting a dark—or any value area when it's partially finished; otherwise you'll have value "break-ups" with awkward contrasts within an area that should be a single value with color changes.

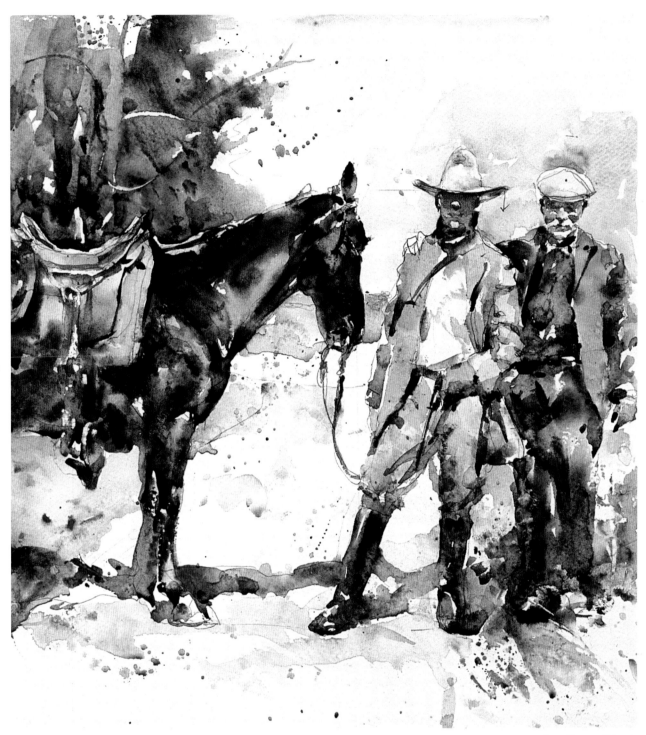

**Low-Country Friends**

# 11 Finish

Every painting should have about one half of the edges lost and one half found or hard edges.

Most of the middle darks and darks are mixed on the paper. Use areas of pure color in your darks. Every value area or object should have an "escape route" where there is a lost edge that connects that shape with adjacent shapes.

# Adjusting Values From Photos

When I'm between inspirations, I'll often repaint favorite photographs (like this one of John Singer Sargent painting at the Austrian Tyrol). Painting multiple pieces from one photograph gives you good practice adjusting values as well as using different color combinations.

Black-and-white photos condense subtle and sometimes distracting value differences between darks and mid-darks into a single value.

Squint at the scene before you. You'll see all mid-darks and darks merging together, while certain lights remain distinct. Do this repeatedly as you paint, so you can capture the merging values while the paint is still wet. You can't successfully soften and lose edges once they're dry.

As I was doing this sketch, I studied two of Sargent's paintings from this trip, both of tents. I wanted to check what colors he used in his tents to help with colors for the umbrella. Both paintings are luminous. One has subtle cool and warm colors while the other is almost monochromatic. No matter what colors Sargent used, his paintings are always symphonic.

Good painting isn't about color, but rather about the selection of values in relation to one another. My goal here was to paint sunlight and make my picture luminous. To do this, I lightened certain darks within the shadows by at least one value. (see *Value,* page 20.)

Don't make values within the darker shapes in the photo as dark as they seem. (This same "rule" is true when working from life with a strong light shining on the subject.) Keep luminosity in mind. You don't want dark, turgid shadows. I pretend that there's a mystery light shining into my shadows.

I usually stay faithful to where dark meets light in photos. I always start painting with areas of strong value contrast and use firmer edges. Dark areas created by cast shadows—as on the cheek in this example—will normally have firm edges.

You'll see that I did *not* copy the hard, dark edge of Sargent's shoulder where it met the umbrella. If you squint, you'll see these areas are relatively close in value, and that the Panama hat against the umbrella actually provides a stronger contrast. So, I softened the edges in the area where the shoulder and umbrella meet. The harder, more prominent edge is between the very light hat and the middle value of the umbrella. Never decide on the firmness of an edge without squinting and comparing it to another edge.

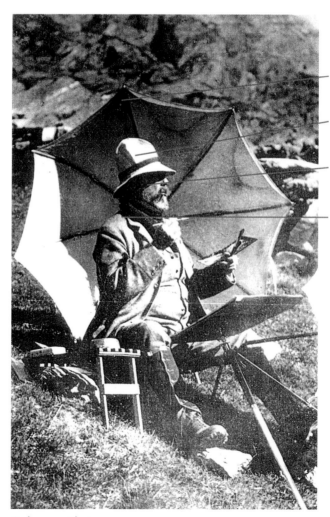

Darker value

Stronger value contrast with hard edge

Cast shadow with hard edge

Strong value contrast with hard edge

Reference Photo

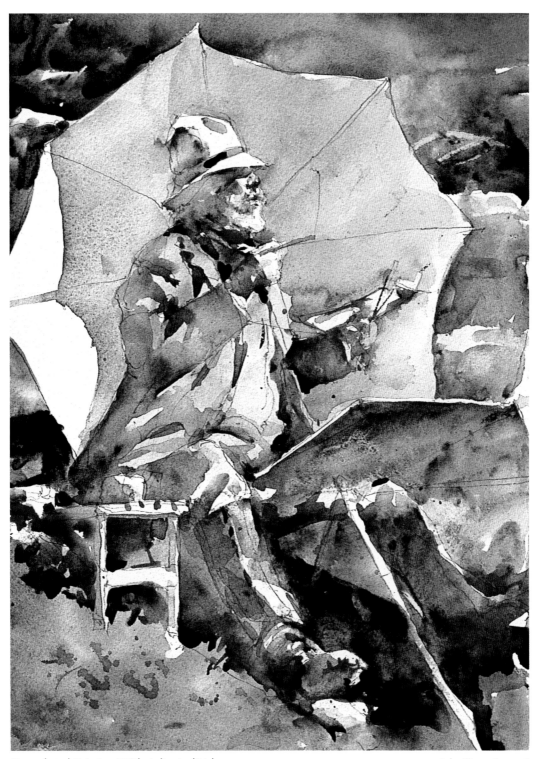

## Completed Painting With Adjusted Values

To make my painting more luminous, I lightened some of the values, especially in the umbrella and the figure.

**John Singer Sargent**

# Planning Lost and Found Edges

To avoid a rigid painting, you must lose some edges. There's so much to think about when painting—everything from color and paint consistency to value and proportion—that your natural desire will be to define every boundary. To prevent that, plan where you'll need to lose edges before you begin painting. If it helps, you can make a contour drawing, using the lines to identify these edges. You can pencil an X over a line, erase the line or leave the line off entirely wherever you have a lost edge.

I've come back to the black-and-white photograph of John Singer Sargent to illustrate how to plan the placement of lost and found edges.

Squint at the photo for about five seconds and then look away. Where are the three most obvious contrasts you remember? I'm limiting you to three; there are many contrasting forms in the picture, but I'd like you to find the three most essential ones.

Hopefully you'll have chosen:

1. The light side of the hat next to darker umbrella.
2. The right hand and light coat and vest next to the darker umbrella, scarf, and shadows in his left arm and clothing.
3. The left side of the umbrella where the light meets the cast shadow.

Squint again for five seconds, then look away. What areas seem to merge together? Remember them, and leave those lines off of your edge placement drawing.

I've left out "in between" boundaries such as the one where Sargent's back meets the umbrella's cast shadow. I usually lose a boundary if it's difficult to see when I squint.

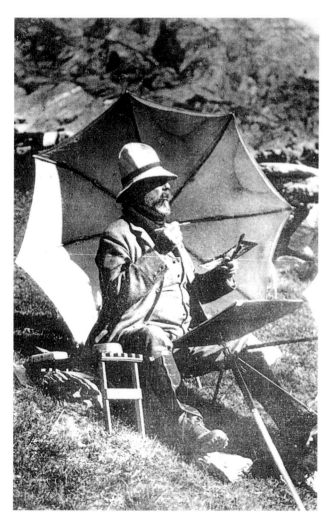

**Simplify the Search for Edges**
Black-and-white photographs make locating boundaries easy. True contrasts (which will become your hard edges) are obvious, while darker midtones merge seamlessly with darks (areas where you can lose edges).

**Keep Values Distinct**

Make clear decisions between light lights, mid-darks and darks, with no "almost" lights or "almost" darks. Repeat to yourself, "Light is light and dark is dark."

## Planning Your Lost and Found Edges

When planning edge placement, I draw the obvious contrasting values and leave out boundaries between areas of similar value.

**a.** Found edges
**b.** Lost edges
**c.** Bridges between areas of similar value
**d.** A choice between lost and found

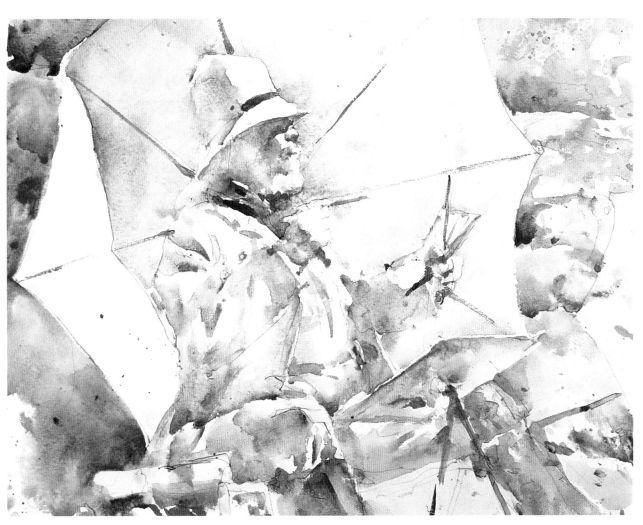

Tuesday Morning

# LANDSCAPES

Bob Painting Camilla, Cortez and Pauleno

# Painting an Outdoor Scene

I once had a teacher who often said, "So much to do with so little time in which to do it." This is a good thing to keep in mind when you're working on location. As you draw, think about how much you can successfully paint in the allotted time.

The following pages contain several of my students' interpretations of a scene in addition to my own.

## Prague's Old Town Square

This day spent painting in Prague's Old Town Square was far more of a trial than most. The square was filled with Scottish soccer fans celebrating before an evening match with the Czech team.

Despite the chaos, the class seemed all the more focused while still enjoying the energy. When a falling soccer ball collided with Mary, a senior, she returned it with a kick that earned her a kiss and a team scarf from the Scots.

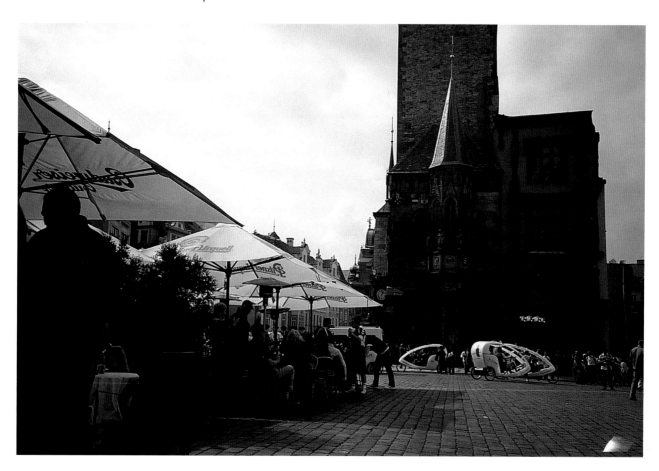

### Capturing a Scene

Boats and trucks always move and the light always changes, but to capture the true energy of a scene, paint what you see with accuracy and care. Never paint what you imagine you see, unless it's an imagined painting.

## Value Studies

These monochromatic studies are intended to help you understand what you are looking at before you make changes to suit you.

I wanted the class to squint so that they could see the church, distant buildings to the left, and the umbrellas as simply as possible. I started at the top of the church with a mid-dark wash of Payne's Gray. (For this exercise, you must start with the mid-darks and add the lighter values later.) Working in the mixing area of your palette, mix a ratio of 75–80 percent wet Payne's Gray to 20–25 percent water. You'll find that the wet wash may look too dark, but it will lighten considerably as it dries. Try not to add more water, but use the mix on the palette. If you must add more, you'll need to add more Payne's Gray. Keep your brush on the paper! Try not to lift as you brush with a zigzag stroke downward from each side of the building . Hopefully, your building will be getting lighter as you reach the bottom.

Leave white paper toward the base of your buildings so you can add figures later.

Don't change the overall simple idea of your value sketch by adding little details. Don't let mid-darks creep into the umbrellas; they must stay luminous.

## Color Study

Here I've suggested a lighter. more impressionistic approach for the class to follow. This approach might suit a situation such as this, with changing light and limited time, especially when there are crowds of people to distract you. I think two and a half hours is about it.

We want a mid-value so you need enough water to let the colors mix but enough paint to identify individual colors.

I use primary colors with definite suggestions. Remember that color is personal and the ones that I chose might not work for you.

For this exercise, think mostly of the value of your earth colors or the blues on your palette. Don't worry about the subtleties of hue or the relative transparency of the color.

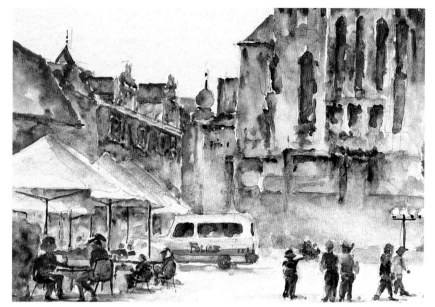

**Student Painting**

## Capturing the Spirit

This painting gets an A+ in catching the spirit of the square with excellent color and very expressive figures. The values are good, but perhaps there are too many small value contrasts that could have been minimized or left out. The artist was too interested in telling us everything. This said, I think this a delightful painting, filled with energy and life.

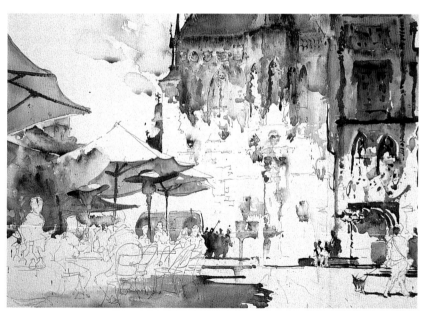

**Student Painting**

## A Great Start

John is a fine painter. This watercolor is unfinished, but what a great start! It's filled with light and energy.

Just some thoughts on procedure: I think it's dangerous to finish a finely painted section, such as the church, and then stop and go on to another section, such as the umbrellas, and then move to the foreground darks. It would have been better to continue with the church, lightening the values until they connect the background shapes and the sunstruck umbrellas.

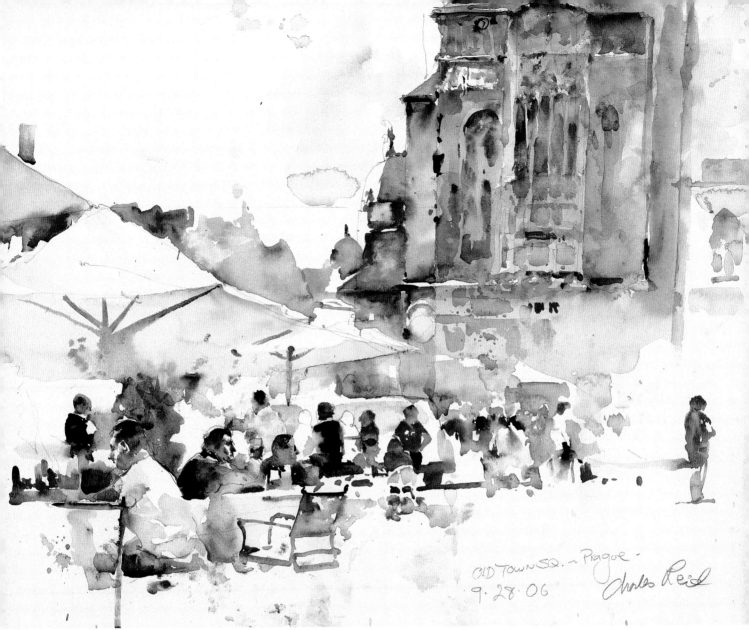

Old Town SQ. ~ Prague.
9.28.06                    Charles Reid

**Old Town Square, Prague**

## My Painting

I chose to tell the story of the people we saw, capturing the bustle of the square without showing every detail. The figures display the strong value contrast to emphasize the "busy-ness" of the crowd. The transition from the people to the church is a lighter, smoother gradation. The lively figures melt into the solid timelessness of the church.

# Look For Light and Shadow

In normal life, we see objects. It's hard to switch gears and think in terms of seeing the shapes of lights and darks. When we draw with a pen or pencil, we do consider the contours of an object, but when we paint we must also think of color and value shapes.

## Some Simple Guidelines

- In direct light: Observe carefully so you can see as much as possible. Notice defined edges and value contrasts. Add more detail.
- In shadow: Don't stare into the shadow areas; you'll see too many small forms. Squint and compare what you can see in the light to what you can't see clearly in the shadows, then simplify the shadow areas. Think of a single overall shadow value. Any necessary details within shadow areas should be added later—with great caution.

### Shadow Behavior

Cast shadows, formed when an object blocks the sun or light source, usually have hard edges. Notice, however, that shadows tend to describe the surface they lie upon. If a shadow lies on an angular form, it probably will have hard edges. If a shadow is on a more rounded surface, the edges will be softer. Within shadow forms, always use softer, lost edges.

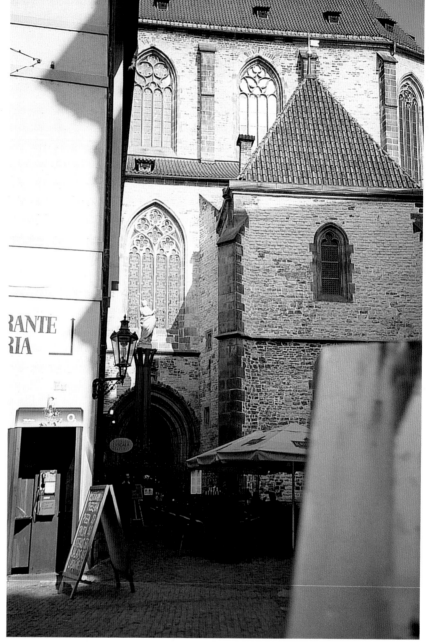

Reference Photo

This photo shows a bright, sunlit scene. Compare the shadows in the photo to the painting.

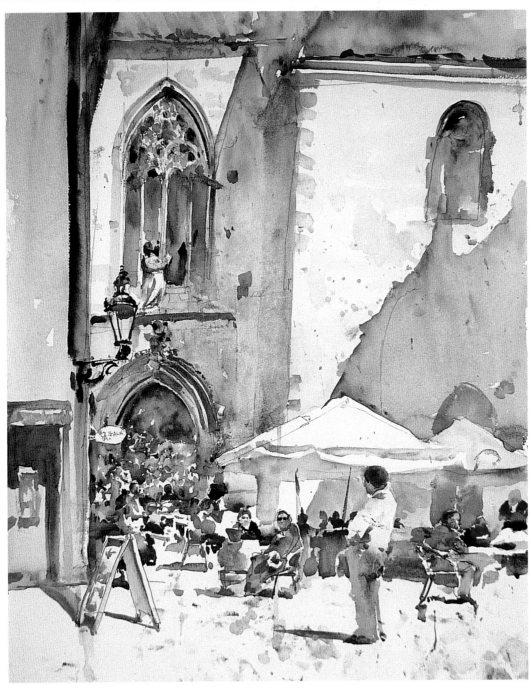

**Near Old Town Square, Prague**

## Working With Changing Light

This scene was totally in shadow when I arrived, so I began by painting only those areas that would remain mostly in the shade: the flowers and the people under the arch. I left white paper for highlights even though I couldn't see any there at the time.

As the sun began to hit the right wall of the church, I decided to paint the shaded left wall, hoping its darker value would "frame" the lighter sections to come. Notice the hard edges on the cast shadows. Once you've painted your shadows, don't alter them, though they may change with the light.

Usually, I add more detail to well-lit areas. In the case of the building on the right, however, I decided to lose the detail because I didn't want to darken the value or allow that area to become too busy.

93

# Working With Values En Plein Air

This church near Santa Fe, New Mexico offered a challenge to me and fellow artists Doc Weaver and Young Woo. I decided to include them in my painting. Sunlit adobe walls can be difficult to paint, with their rather deadly light values and sandy hues.

Reference Photo
Doc is standing by the wall and Woo is peering over. You can tell by their expressions that painting outside is fun—at least before you start.

## Why Start With Mid-Darks and Darks?

All of the landscapes in this book were done outside, on the spot, with bugs, wind and changing light. There was no time for glazing. Here are some other things to think about when you're painting en plain air:

1. It's very hard to judge the proper value of a light wash when there is only white paper to compare it with. You'll probably make the wash too dark.
2. White paper is precious. Once you've covered it with a tone, it's gone. Many colors won't lift cleanly, and Opaque White works only in very small spots.
3. The best course is to start with mid-darks, leaving white paper areas for the mid-lights and lights until the end when you can judge the lighter values in relation to the darker values. Think of a house. The shadows, cast shadows and adjacent darks are like the foundation and interior supporting beams of the house. The lights are like the siding and whatever color you choose to paint the outside of the house.

Reference Photo
This is the vantage point I chose for my painting.

**New Mexican Church, Santa Fe**

## Starting With Darks

I started with the darks in the distant hills and the shadow shapes in the building, then added the light tones. I then painted Doc's figure over the light tones on the building.

I decided to avoid painting the adobe color out in the light, leaving white paper instead. I also "invented" colors for the shadows, especially the blue where the cast shadow meets the light in the large building. I used Cobalt Blue right from the tube and created a hard edge. Cast shadows usually have hard edges when the shadow is near the object casting it.

I wanted to reflect the strong Cobalt Blue in the sky in my shadows to create a connection between the warm building and cool sky colors. I don't believe in making one section of a painting warm and another cool. Whenever possible, there should be warm and cool notes throughout a painting. An exception would be in the very blue sky.

You'll see that once I got into the shadows, I used some warm colors: Carmine (Holbein) or Alizarin Crimson, and Raw Sienna. I also applied Cadmium Yellow Medium under the roofline.

When the shadows in the building were dry, I applied a very light wash of Carmine with touches of diluted Cadmium Orange. A wash like this should add just a blush of color over the white paper. I painted Doc's figure over this very light wash after it was completely dry.

# Jan Hus Monument, Prague

Latislav Saloun's monument to Jan Hus in Prague's Old Town Square is a beautiful, moving sculpture with the rough strength of a Rodin. A brave religious thinker, Jan Hus was excommunicated and burned at the stake nearly six hundred years ago.

This an important exercise for a couple reasons:

- It will help you see shadow and cast shadow shapes. Once you can see these shapes, you'll come to understand their central place in picture making. If you make accurate shadow shapes, you'll make good figures without having to think about the figures themselves.

- It will help you learn about the proper ratio of water to paint. It will also help you keep the brush on the paper. Many students stop between adjacent sections of the figure rather than seeing the connecting shapes of shadow.

### Planning the Composition
This is the view I used for my demonstration. I decided to silhouette the standing figure of Jan Hus against the sky, with the remaining figures overlapping the church.

I knew I'd have to lighten any competing adjacent window shapes behind the statue figures. I was lucky to have full sunlight to create shadow shapes in the statue and church. On an overcast day, we'd see too many small forms and details.

### 1 Contour Drawing
Draw the silhouette of the monument with a single line, starting with the Hus figure on the left. Keep your pencil on the paper. (See *Contour Drawing*, page 14.)

I use the height of Hus's statue as my guide for the heights of the other figures. A transparent ruler held horizontally in relation to the bottom edge of the drawing will help you line up the remaining heads. The dots you see in the drawing are where I stopped, not lifting the pencil, to check the angles and the distance to travel before the next shape change.

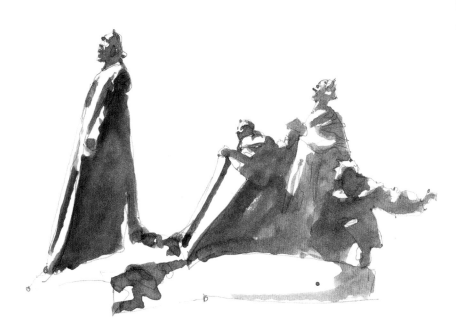

## 2 Do a Value Study to Find the Shadow Shapes

Use Payne's Gray or Ivory Black so that you can concentrate on values without worrying about color.

Use a no. 2 or no. 3 round for the heads and a no. 4 or no. 6 round for the larger shapes. The brush *must* come to a good point when wet.

Mix the pigments with a little water on your palette. Make the mix darker than you think necessary because the wash will dry lighter. Practice with a few swatches to see how much paint you'll need in the mix to get the mid-dark value.

If you're confused by a mid-value that lies next to shadow, treat it as a light. Paint only the obvious shadow shapes. Some shadow shapes within the sculpture will be isolated, but find shadow connections between them. You'll get some variations in value within the shadows when you need more paint or switch brushes.

## 3 Emphasize the Monument

The monument was my primary interest. I didn't want it to be lost in the clutter of small darks behind it, so I lightened all of the windows and the dark red roof of the church.

You'll see I haven't followed my value study in the central part of the statue. I thought that parts of the statue should tie in with the church. I did the study to help you see the actual shadow shapes in the photo. First you should understand what you see, then make any changes the painting needs.

I used a triangular composition. The dark roof and the Hus figure on the left lead the eye up to the church spires, then down to the extended hand and small figure in the red shirt on the right.

**Jan Hus Monument, Prague**

# Keep It Simple

Andrew Wyeth is a master of simplification. I looked at a book of his paintings of Maine and realized that he usually painted one only subject, using only two contrasting values. Sometimes the large light shapes dominate; sometimes the large dark shapes dominate. When you look at a Wyeth painting upside down, you can see a wonderful abstract design of two simple shapes with contrasting values.

With Mr. Wyeth in mind, I've taken a student's well-painted but overly complicated painting and sketched two of its subjects separately.

I never make pencil compositions when planning a picture. Instead, I create small color sketches like the ones shown here. They help me plan my colors and values more effectively than pencil.

### House at Gundy's Harbor
The bridge and the rocks, the shed and the truck, and the house on the hill that are all depicted in this painting would have worked better as separate paintings.

**Student Painting**

### Keep It Small

The bigger the picture, the harder it is to simplify. When working outside, limit yourself to quarter sheets of paper. Simplify, and then simplify some more. Can you make a picture with only two simple shapes—one of connected darks and one of connected lights?

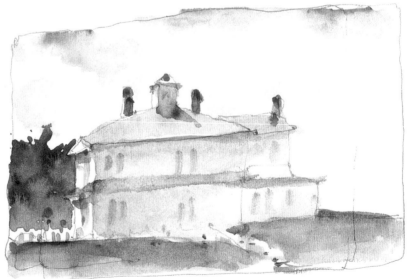

### Simplifying the House
Remember that details get lost and colors fade with distance. Notice that I've either lightened or lost details such as the shutters to create a sense of distance and to avoid cluttering the essentially white building.

I've darkened the grass on the horizon at the right, the chimneys and the cupola, and the cast shadow next to the house to stress the whiteness of itself.

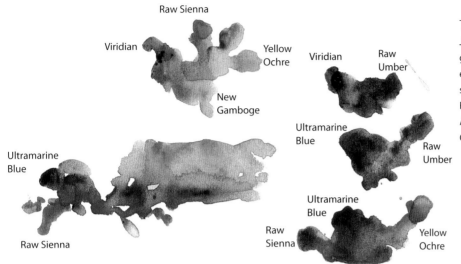

Raw Sienna

Viridian
Yellow Ochre

New Gamboge

Viridian
Raw Umber

Ultramarine Blue
Raw Umber

Ultramarine Blue

Raw Sienna

Ultramarine Blue

Raw Sienna
Yellow Ochre

## Try These Hues for Your Greens

John Singer Sargent used only Viridian for his greens, so I've tried it here, along with several earth colors and blues. Cadmium Yellow is very strong. Try mixes of Viridian and Yellow Ochre, Raw Sienna, New Gamboge and Raw Umber. Also try the earth colors with Cerulean Blue, Cobalt Blue and Ultramarine Blue.

### Look for Shapes, Not the Subject

Turn your sketch upside down to see if it has good, simple, connected abstract shapes.

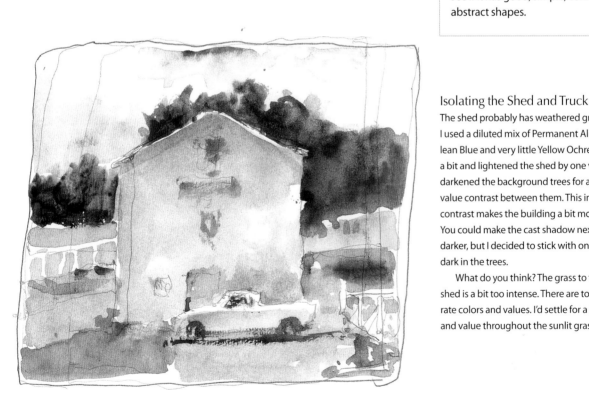

## Isolating the Shed and Truck

The shed probably has weathered gray shingles. I used a diluted mix of Permanent Alizarin, Cerulean Blue and very little Yellow Ochre. I cheated a bit and lightened the shed by one value, and darkened the background trees for a stronger value contrast between them. This increased contrast makes the building a bit more luminous. You could make the cast shadow next to the shed darker, but I decided to stick with one dominant dark in the trees.

What do you think? The grass to the left of the shed is a bit too intense. There are too many separate colors and values. I'd settle for a single color and value throughout the sunlit grass sections.

### Experiment

Repeat my sketch but try a darker cast shadow by the shed.

# Adjusting the Composition of a Scene

Before you paint a scene, decide what interests you most. What first caught your eye? What part of the scene will be difficult to paint, or will detract from the overall composition? Skip that part if possible, or find a way to deemphasize it. If there's an object you'd like to move, check the values and colors around it first. Avoid moving objects to areas where the background values would be too similar. Remember that light-value objects in particular need to be surrounded by darker values that help to define their forms.

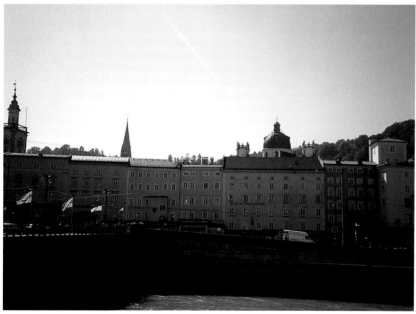

## Choosing the Most Interesting Elements

From the photographs of Salzburg's Old Town, I wanted to include the castle in the background and the bridge in the foreground. I also liked the skyline and the building with the clock tower and cupolas, and the interesting dome in the second photo. However, all these elements were too far away from each other to form a good composition—and then there was also the problem of that long row of dark-value buildings, and all those windows. What to do?

I decided that I would need to move some of the buildings closer together. I couldn't move the building with the cupolas away from the hill beneath the castle because I needed the dark, bluish value of the hill to give form to the light-value cupolas. Instead, I decided to move the big dome closer to these other elements. I also decided to leave out the narrow spire between the clock tower and the dome to create a more pleasing sense of space.

View of oldtown · Saltzburg
Sept 27, 06 Charles Reid

## Leading the Eye With Values

I wanted the skyline and the bridge to be the main areas of interest, so I created the most value contrasts there. I didn't want the middle section of the painting to be too dark, so I lightened the values in the row of buildings and skipped over most of their details. Mixing Cerulean Blue, Raw Sienna and either Carmine (Holbein) or Permanent Alizarin Crimson with a lot of water on my palette, I painted light washes on one building at a time, subtly varying the color from one building to the next. For the windows, I added single strokes of mid-value Cerulean Blue or Cobalt Blue, using a semidry brush. (See the color swatches on page 103.)

**View of Old Town, Salzburg**

# Three Practice Sketches

This demonstration exercises your touch with the brush. Let the paint do the work and concentrate on perfecting your stroke. I employed this technique in my painting of Old Town Salzburg and I must say, I use a variation of this quite often in multiple subjects.

Use long strokes. Make sure they will dry dark enough!

Burnt Sienna or Burnt Umber

Ultramarine Blue

No. 6 round brush with a good point

## 1 Practice Your Initial Stroke

Make a very dark mix on the mixing area of your palette with Burnt Umber and Ultramarine Blue. (You'll need wet paint in your mixing supply.) Use a no. 6 or no. 8 round that points well.

Load your brush with the dark mix and make a long, diagonal, downward stroke without lifting the brush. Note the position of my brush as it makes the stroke: it's pressed down almost to the ferrule. Practice this before going on to the next step.

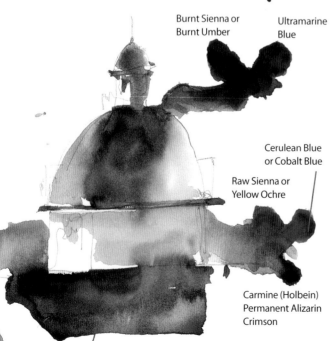

Burnt Sienna or Burnt Umber

Ultramarine Blue

Cerulean Blue or Cobalt Blue

Raw Sienna or Yellow Ochre

Carmine (Holbein) Permanent Alizarin Crimson

Burnt Sienna or Burnt Umber
Ultramarine Blue

## 2 Practice Your Softening Stroke

You should have quite a bit of dark paint in your mixing area. Rinse your brush and give it two definite shakes with your wrist locked. *Don't* dry the brush on a tissue; it will take too much water from the brush. Working quickly, lift your damp brush so you're making a single softening stroke with about half the length of the brush pressed to the paper. Don't use the tip! We want to let some of the dome color on the shadow side seep into the lighter building and into the roof, but don't worry about this at first. See if you can get the dome looking sort of like mine. It is necessary to load the brush with a lot of paint, but also a decent amount of water. Don't be discouraged; this is difficult.

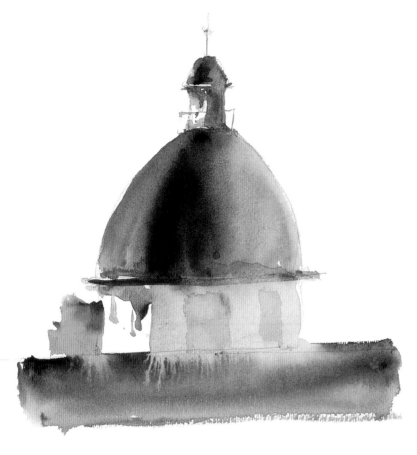

## 3 Practice Modeling the Forms

Remember to squint so you can see value changes more easily. Notice that edges are harder and darker shapes are more definite where they face the light (top right).

Try to leave your painting alone and let it paint itself. Use plenty of dark paint in the roof, but let the light part above seep into it. Just watch without interfering.

### Remember Your Light Source

When painting, it's easy to forget the main direction of your light. Don't!

Permanent Alizarin Crimson or Carmine (Holbein)

Raw Sienna or Yellow Ochre

Cobalt Blue or Cerulean Blue

### Color Swatches

Here are the colors that I used in my demonstration and in my corrective sketches.

Mix used in light part of building

Burnt Sienna

Ultramarine Blue

### Keep Your Brush Down

Use single strokes with the brush anchored to the paper; don't lift until the end of the stroke. This principle applies to your initial stroke as well as to your softening strokes.

Mix used in the dome, cupola and roof

# Creating a Value Sketch

I made this value sketch for a morning demonstration at Mirror Pond in Bend, Oregon.

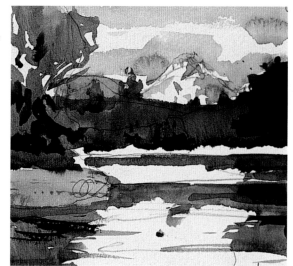

## Capture the "Big Idea" in a Value Sketch

Value can make or break a composition. Painting a thumbnail sketch using one color—capturing the "big idea" of the composition—helps establish the most obvious contrasts of lights and darks, and keeps you from getting confused by smaller, subtler variations within the values. Try to keep all the darks connected.

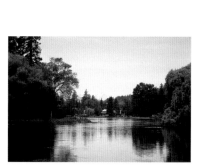

Reference Photo

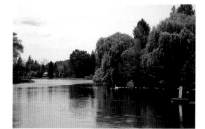

Reference Photo

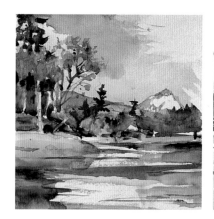

## Include More Subtleties in the Color Version

Your color version need not be an exact copy of the monochromatic value sketch. Once you've found the values, you can paint what you want to see and include more subtleties. Think of the land and its reflection as a combined shape as you paint wet-in-wet. After it dries, find a subtle separation between the land and its reflection.

### Sky Colors
Cerulean Blue above, warming toward the horizon with Alizarin Crimson and Cadmium Orange.

### Light Greens
Cerulean Blue, Cadmium Yellow Pale or Cadmium Lemon.

### Basic Tree Color
Raw Sienna, Viridian, New Gamboge and Cobalt Blue.

### Tree Reflections
Ultramarine Blue or Viridian with Raw Sienna and/or Raw Umber.

### Rock Formations
Carmine or Alizarin Crimson, Cerulean Blue or Cobalt Blue, and Raw Sienna or Yellow Ochre.

# Avoid Overworking

I never make pencil preliminary drawings since the placement of objects isn't as important as the placement of color and value shapes. Unfortunately, preliminary color sketches are often better than the final product. I suppose we try too hard in our "finished" paintings.

### Reference Photo
The bright sunlight gave me strong cast shadow shapes. On an overcast day, you won't see shadows like these, so you may end up painting windows and small details.

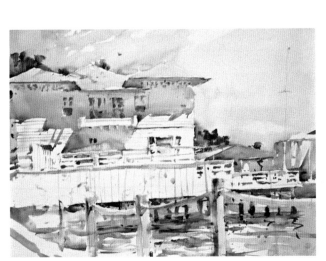

### Preliminary Sketch
Compare this sketch to the finished painting at right. I like the warmer spots of color behind the buildings and the warmth under the roofline in this version, but the water is too confused and busy. I wish I had a larger, darker, simpler shape for the water, and more of the light-value walkway.

### Finished Painting
The painting looks too cool, but aside from that, I'm satisfied with it. I simplified the water into an overall middle value. The light shape of the walkway and the dark shadow and cast shadow shapes in the buildings almost meet my goal of 75 percent large simple shapes.

**Catalina Yacht Club**

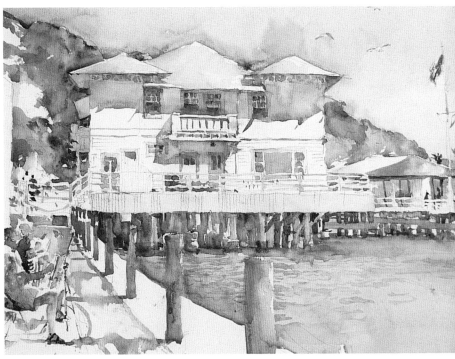

# Limiting Value Changes

Minimize the number of times you change values in a painting. If you see four or more values, squint to see if you could combine some of them so that your composition will be more unified.

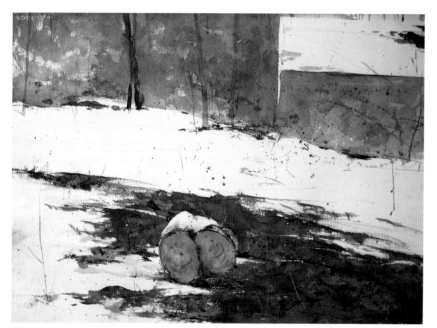

## Value Is Critical

Color isn't really important when compared to value. This is one of my early paintings when I was concentrating on values and losing and finding edges. There's almost no color variation, but it's a striking painting.

The white paper gives such a wonderful contrast to the mid-darks in the log, the trees, and the house in the background, as well as with the dark value of the patch of grass revealed by the melted snow.

**Log—Greens Farms**

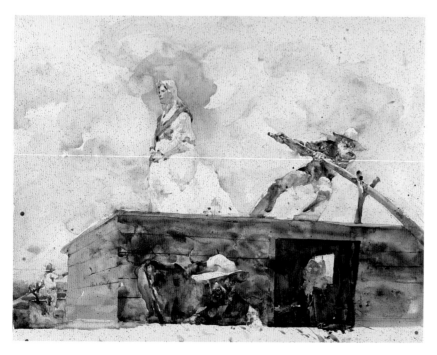

## Values Support the Story

Here I used simple values to support the "story" of the painting. I wanted the riverboat, the cow, the rough men manning the boat and the elderly lady in the cabin to contrast with the young woman gazing toward the future and her new life in Oregon. (It might sound a little corny, but it was a great deal of fun to paint.) The young woman is a large shape, and the only figure with a light value. She becomes the center of interest because she's unique.

Andrew Wyeth's wonderful compositions inspired me often. He divided them in half, making the bottom part dark and the upper part light. I followed this rule here, but concentrated mainly on the relative sizes of the two shapes of light and dark in relation to the entire picture space. Establish the big, simple shapes first; they will grab the eye. Then add the interesting smaller happenings within the big shapes to tell your story.

**Missouri River Boat**
Courtesy of American Heritage

# Connecting Shapes

So many students separate elements in a their paintings according to the identity of the subject. In reality, of course, a boat is one thing and water is another thing. But painting isn't about reality; it's about perception. Distinct objects may be perceived as one shape when their values are similar.

One of my "usually true" rules is that a painting with 75 percent large shapes and 25 percent small shapes will be more effective than a painting with 25 percent large shapes and 75 percent small shapes. Busier, fussier paintings tend to be less effective.

A good way to make larger shapes is to connect areas of equal value.

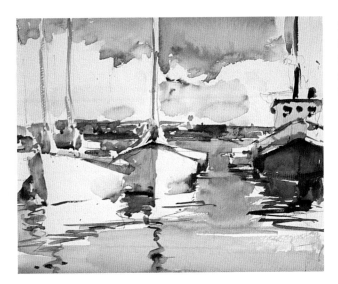

### Simplifying the Value Shapes
In this initial sketch, I concentrated on the white boats and their white reflections. There were obvious connections between the shapes, regardless of the identity of the subject.

### Complicating the Scene
We all want too much when painting a "finished" piece. I was intrigued by the ripples in the water, but I wish I'd left the water as simple as I had made it in my sketch. The shapes here are more separate, each object more distinct. Because the shapes are broken down into smaller pieces, the scene is busier.

**The Center for Wooden Boats—Seattle**

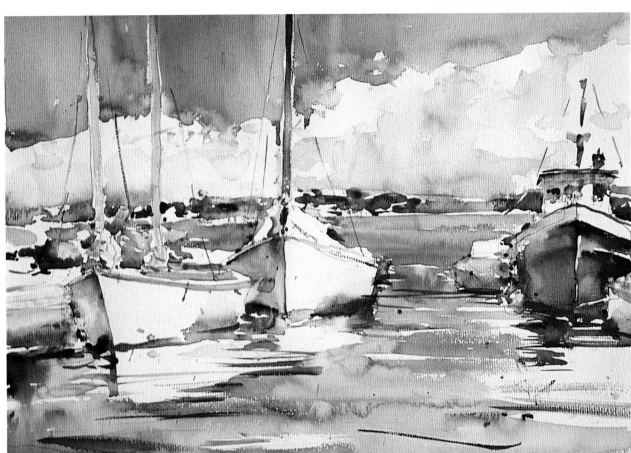

# Creating Connections Between Value Shapes

Fifteenth-century artists such as the van Eycks, Robert Campin and Piero della Francesca painted with a flat, two-dimensional picture plane. The idea of a third dimension to the picture plane didn't occur to painters until the end of the fifteenth century. Paul Gauguin and his followers, Edouard Vuillard and Pierre Bonnard, reverted to a flat or two-dimensional picture plane at the end of the nineteenth century.

These early and more recent painters relied on the juxtaposition of color and value shapes, weaving a pattern of connected and contrasting forms that led the eye through the picture.

I'm intrigued with the idea of "weaving" used by these two-dimensional painters. They placed lights next to other lights, darks against adjacent darks, darks next to lights, and lights next darks, without any apparent effort to create space or perspective. Nor is there an effort to establish a "center of interest."

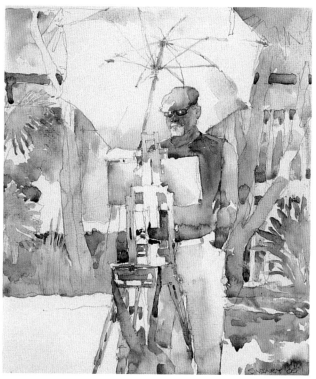

### Two-Dimensional Values
This is basically a two-dimensional picture. It would have been best to trace the light and then the dark shapes, finding where they connect with comparable value shapes. Find adjacent shapes that contrast in value.

**Student Painting**

## Journey to a New Dimension

In the art section of your library, find picture books with fifteenth-century Renaissance paintings. Look at reproductions of works from the early Renaissance to later masters such as Leonardo da Vinci. Observe the amazing journey from a two-dimensional picture plane to a three-dimensional picture plane that occurred in a very short period of time.

## Emphasize Value Shapes, Not Objects

These porch paintings depend on sunlight. On an overcast day you can't avoid seeing things, but with the sun you'll see shadow and cast shadow shapes that will give you interlocking forms of lights and darks.

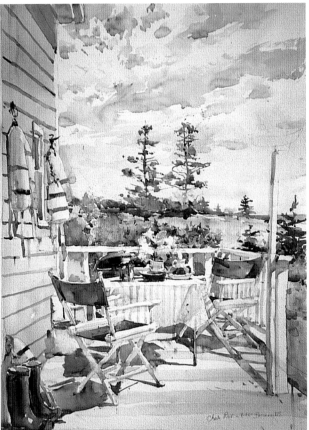

**Baccaro Porch Paintings**

# Establishing Value Guides

Establish definite whites and definite darks, then decide on the values in between. It helps to have objects that anchor the value range. In the scene below, I used the dark boat as my value guide for the darks. This is the darkest large shape, so it becomes my point of comparison for other darker and middle values in the water, boat, dock and reflections. The sailboat hulls are the lightest shapes. For them, I preserved the white of the paper. They became the point of comparison for the lighter middle values.

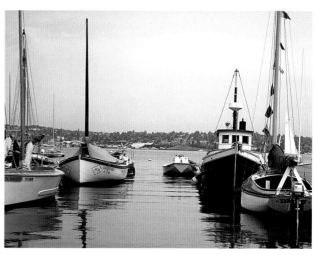

**Reference Photo**
Squint at the photo to identify the values. Where are the darkest darks? Where are the lightest lights? The rest of the value range should settle between those extremes.

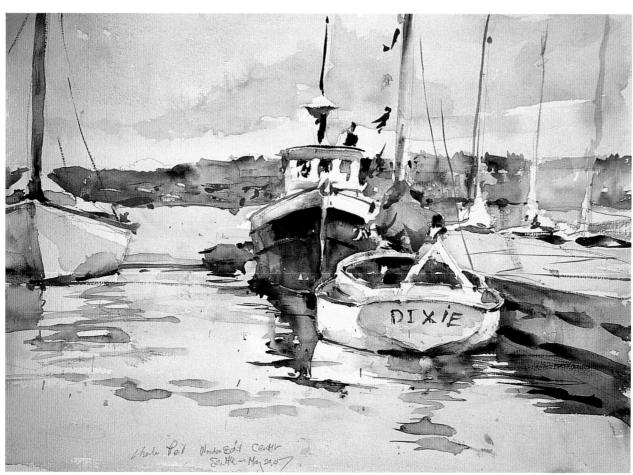

**Identify Your Value Guides**
The dark boat was my value guide for darks; the white sailboat hulls were my lightest light. On an overcast day, the water ranges from middle to light-middle in value.

**Boats at the Center for Wooden Boats—Seattle**

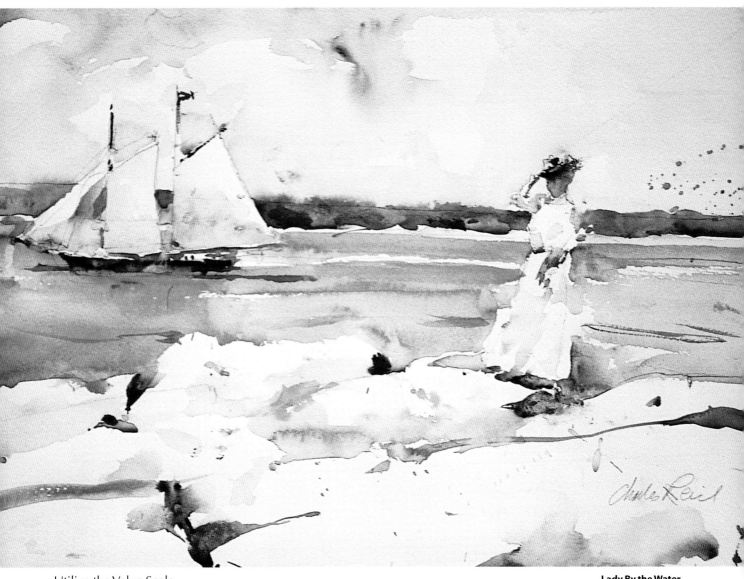

## Utilize the Value Scale

Keep white paper for the rocks, adding a few cracks. The woman's dress should be white paper as well. The water should be about two values darker than the rocks, about value 3 on a six-point value scale (see page 28). The distant land should be value 2 and the sky value 5.

**Lady By the Water**

# Painting Water

Water should be painted with hard edges between the light from the sky and the darker or lighter reflections from trees, buildings or boats. Paint wet-in-wet within the reflections but very rarely where the reflection meets the light from the sky.

Values are just as important when painting water as when painting anything else. Save your lightest lights as white paper, but retain a connection with the adjacent darker values so your light shape doesn't look like a cutout.

Never let the small light areas within your darks and the darks within your lights confuse you. Always squint. Make sure you understand the overall value of an area regardless of the small confusing details that you see when your eyes are wide open.

## The Many Colors of the Sea

For distant water on the horizon try moist Antwerp Blue or Peacock Blue (Holbein). Sometimes I use Ultramarine Violet if the horizon line of the sea seems very dark.

In shallow water, use diluted Antwerp Blue, Peacock Blue or Winsor Blue. These are all transparent blues that retain their color identity when diluted.

Sometimes water near the shore can turn a delicate turquoise green. You can add Turquoise Green to your palette but diluted Cadmium Yellow Pale or Lemon Yellow can be mixed with one of the diluted blues to achieve the same color.

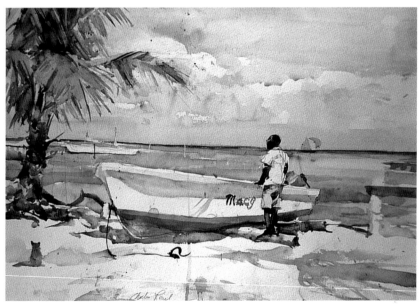

**Macy 2**
Courtesy of Munson Gallery
Chatham, Massachusetts

### Colors of the Sea

The various colors of the sea are easy to identify here. Look for Ultramarine Violet at the horizon, Antwerp Blue and Cobalt Turquoise with Ultramarine Violet by the stern of the boat, and Cobalt Turquoise by the beach.

Use long horizontal strokes, keeping the middle section of the brush on the paper. I don't want too much blending, so I wait between color changes so the strip of color dries slightly.

The cast shadow beneath the boat's gunwales has a hard edge. Cast shadows are usually hard edged and darker near the object that casts them. I use Cerulean Blue, a very small amount of Carmine Red, and Raw Sienna.

The cast shadows on the sand are farther from the tree that casts them, I've softened some edges and made them lighter in value. Don't paint wet-in-wet when you want a clearly defined shape in any cast shadow.

## The Effects of Weather

Overcast days can affect the color of water. I often use white paper for light water on a gray day before adding the reflection of a darker shape. If you do add a tone, it must be very light in value, just hinting at the color. It shouldn't be a dull, neutral gray.

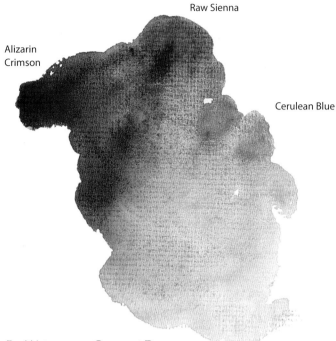

Raw Sienna

Alizarin Crimson

Cerulean Blue

### Practice Swatches

During idle hours, paint swatches. Mix Carmine or Alizarin Crimson with various yellows (Yellow Ochre, Raw Sienna, Raw Umber) and various blues. Painting swatches is wonderful practice. It helps you develop a good paint-to-water ratio and learn how to allow paint to mix on the paper.

### For Water on an Overcast Day

This is how the paints should look on the mixing area of your palette. Make sure no single color dominates. Don't overblend your colors on the palette. The individual colors should still be identifiable. If you have a hand-held palette, the colors should stay put and not run when you tilt the palette. Now shake your brush and work out the mix on another section of the palette until you have a light "warm-cool" gray as seen in the lower right of the swatch.

### Overcast Sky and Water

I painted the sky and water as one, then added the landforms and ship after the sky and water were dry. This was painted late in the day, so I stressed Raw Sienna, Carmine and a bit less blue for a warmer look. For the ship, I used Payne's Gray and Cadmium Red Light, blended wet-in-wet with much more paint than water.

**Container Ship—Seattle**

# Adding a Figure

Adding a foreground figure can save a painting. During a plen air session at a lake in Scotland, I noticed this inflatable boat on a trailer. Boats of any kind interest me, even if they aren't what most people call beautiful. Realizing that few of my class members would want to paint the inflatable, I suggested that adding the figure of someone painting the boat might be an interesting challenge. Most of my students drifted off to more promising sites, but Jean and Don were good soldiers. Unfortunately, I don't have Jean's painting, but as I recall, it was excellent.

**Reference Photo**
Never paint a subject that you don't care about—but don't always paint only what you think will sell.

Scotland has beautiful scenery, but I felt the need to paint something garish and awkward.

## Don's Painting of Jean Painting
This is a very good painting, but it has one significant flaw. My criticism is minor but important. Because the values in the figure and boat are similar, Jean and the boat seem to merge into the same picture plane. This is fine if Don intended his picture to appear two-dimensional.

However, if Don wanted to show his figure in the foreground, the boat in the middle distance, and the hills in the background, he should have considered the relative values of the three planes. Remember that more saturated colors come forward, while less saturated, diluted colors tend to recede.

Don could have kept the boat slightly lighter in value because the darker values compete with Jean. If you wish a foreground figure to come forward, you must use more diluted colors behind the figure.

Avoid using values in your background (negative shapes) that are darker than those in your subject.

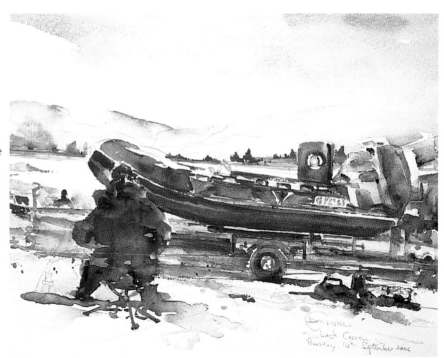

## Color Sketch

I made this sketch of Don painting so see what colors would work where. Sometimes it can be fun to use the colors themselves as values instead of being true to what colors you see.

## Facts of Watercolor Life

I found Don painting on the beach where Judi was painting and set up my easel. It's OK to feel depressed about failures but it's only a piece of lost watercolor paper. Think about what went wrong and try again. So many times I've had students spend two hours on a tired failure then do a delightful painting in twenty minutes.

**Don Painting at Applecross, Scotland**

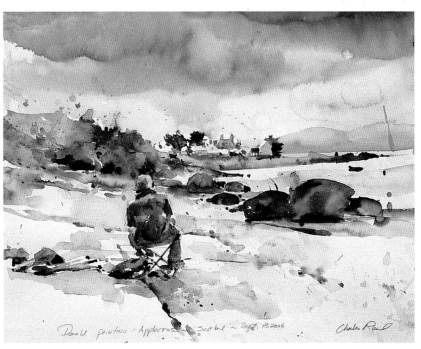

# Figures in Seascapes

The relationship between the sea and a figure can provide a great story for a painting, and make it a lot of fun to paint on location. I like to draw and paint a foreground subject. I use the colors and values in this foreground subject as a guide for the rest of the painting.

When drawing the scene with your figure, don't worry about outlining the objects. Instead, concentrate on the placement of planes of lights and darks by drawing the boundaries of the shadow areas. Try to avoid nuances.

If you're drawing a scene involving a figure and a boat, don't try to draw the whole scene, since the subject will probably get in the boat and sail off. I limit my drawing to the boundary of the boat, the people, the dock, the horizon and the beach, using a single-line contour drawing—no sketching.

Get your brushes, water and palette ready. Be sure to have a spray bottle handy; paint dries quickly on the beach, even when you use an umbrella. Your paper must be shaded. Direct sunlight makes it more difficult to judge values. It's also hard on your eyes, and causes the paint to dry even more quickly.

It's necessary to paint your subjects and the water simultaneously. You need the darker water to define your whites and lighter values. Also, you need to connect the shadows and darks in the subject with the water so you don't get a cutout effect.

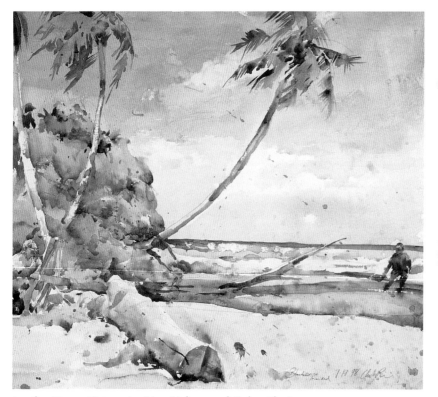

## Use Sketches Instead of Snapshots

Taking snaphots of people to draw later isn't always a good idea. After an unpleasant experience in Mexico, I'm shy about taking photographs of local people. I prefer drawing my people on the spot. Even when the subject comes to look at what I've done, I usually receive smiles and a "That's pretty good, mon."

**Blanchisseuse, Trinidad**

### Let the Figure Determine Your Values and Color Choices
If you have a person in the foreground, like Bob in this painting, draw and paint the person immediately. Don't try to draw in the surroundings. We change colors and values as we paint, sometimes intentionally, but usually by accident. Once you've painted your foreground subject, use its value and colors to determine the background. The hill behind Bob was actually much darker, but it would swallow him if I had painted it that dark, so I lightened its value.

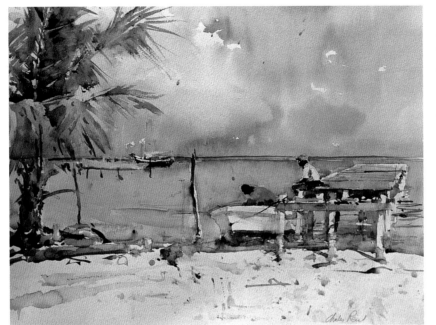

## Contrasting Shapes

The white shirt wasn't a problem since the figure's dark face and legs merge with the darker water.

I wanted the shadow side of the boat to look like a shadow on a white boat, so I lightened the water next to it.

The water is Antwerp Blue. I wanted a simple, mid-dark flat water shape to contrast with the light sand.

**Macy 1**
Courtesy of Munson Gallery
Chatham, Massachusetts

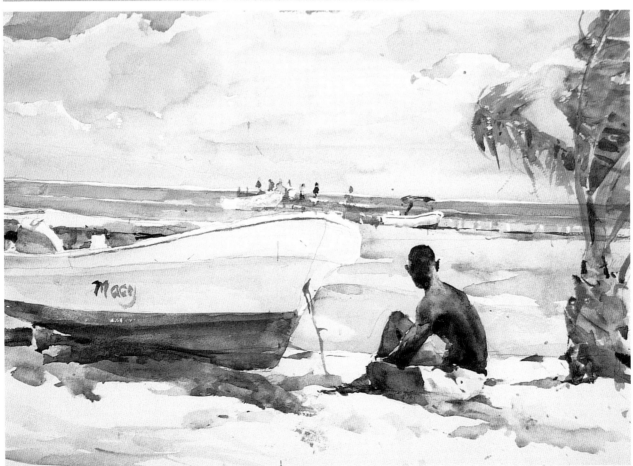

## Concentrate on Value

Natives in Belize, where this series was painted, are often very tall and graceful, with dark blue-black complexions. Outline the shapes of the shadows and make sure there is a difference in value, but keep your light values dark enough to convey the sense of a dark complexion. I use a simple combination of Ultramarine Blue and Burnt Sienna so I can concentrate on value.

**Macy 3**
Courtesy of Munson Gallery
Chatham, Massachusetts

# Combining Scenes

I've drawn and painted figures for years and can do generalized stock figures in my paintings. It's much harder to catch a figure with a unique gesture, but definitely worth it. Figures add life and personality to your paintings. If there is no figure handy in the scene you want to paint, look for appropriate poses elsewhere. I used reference photos to add figures to the scene below.

### Reference Photos
I copied the walking figure and white-clothed mime.

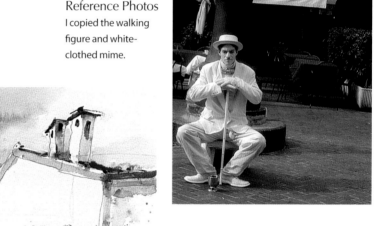

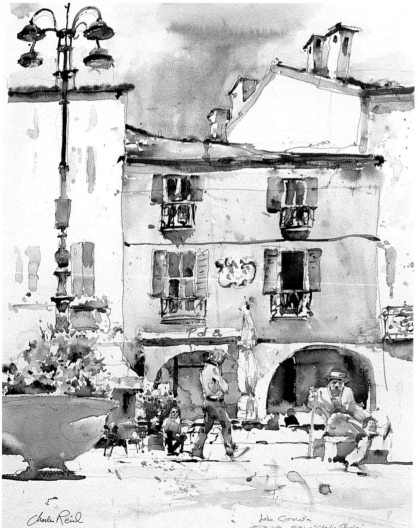

### Complete a Foreground Object to Use As a Guide
I prefer starting with a foreground object: in this case, the urn and flowers. I used the finished urn as a guide for the relative sizes and placement of the figures and buildings. When working on the spot, I like to draw then paint small parts rather than draw in the whole scene. There was a bit of fleeting sun on the urn, so I wanted to complete it before the clouds came along. I like to finish a section to use as my color and value guide for the rest of the painting.

**Cathedral Square, Como, Italy**

For this painting, I decided to use the statue of Count Volta as my starting point. The sky was overcast so I had to invent shadow shapes in the statue. I used Payne's Gray, Cerulean Blue and Cobalt Blue, Raw Umber and Burnt Umber. The colors I used are not as important as the values I used to make the statue dominant. (Squint to find the right values.)

The building with its numerous windows was a distraction, so I lightened the roof and lightened or lost the windows. If I had painted all of the windows as I saw them, the statue would have been lost.

Next, I went to the roof. I started on the left side with Burnt Sienna, Cobalt Blue and Cadmium Orange. The roof was becoming too dominant, so I lightened it by adding some Raw Sienna and a slight amount of water. Payne's Gray and a slight amount of New Gamboge were used in the sky on the right for warmth.

I toned the building with very diluted Carmine, avoiding blue in order to preserve the subtle warmth. (Sometimes I also add very diluted Cadmium Orange for a blush of warmth on white buildings, roads or beaches.)

The foreground figures came last since I'd had such a hard time painting the statue and background building.

I dampened the paper at the border of the tops of the trees for a soft fuzzy edge. Adding trees is always a problem because greens are difficult. Try a mix of Cerulean Blue or Cobalt Blue with Cadmium Yellow or Yellow Ochre. The only green I have on my current palette is Viridian, which I warm with Yellow Ochre or Raw Sienna.

Reference Photos

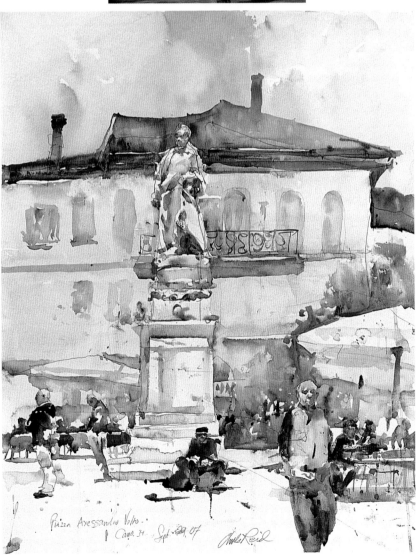

### Piazza Volta
The statue in this square honors Count Alessandro Volta, a physicist who invented the battery. (That's where the term *volt* comes from.) He's a native son of Como.

**Piazza Alessandro Volta, Como, Italy**

119

# Altering a Background

For my foreground subject, I wanted something old-fashioned or nostalgic, so I chose to paint from this black-and-white photo of the carter's boys. I painted the subject first, then, with my class, went out to find a suitable background. A half-timbered, thatched cottage in the local village is what I chose to paint, though a simple landscape may have suited the subject better.

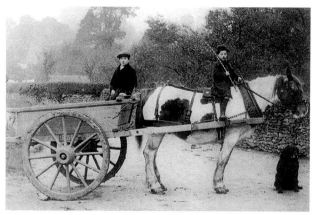

Reference Photo of the Subject

Reference Photo of the Background

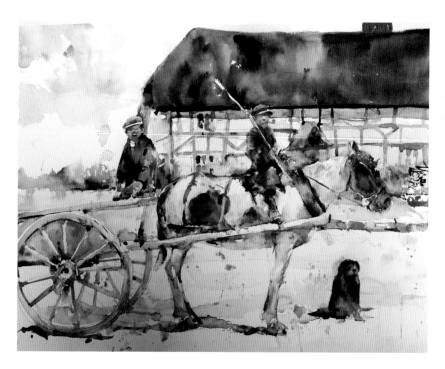

## Combining the Views
I used a limited palette of Raw Sienna, Raw Umber, Burnt Umber, Cobalt Blue, Ultramarine Blue, Carmine and Payne's Gray.

**The Carter's Boys, Urchfont, 1928**

# Selecting Colors

Choose colors that will create a harmonious composition. Avoid colors that are too intense or that will create conflicts in an otherwise peaceful scene.

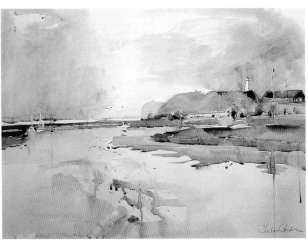

## Avoid Color Conflicts

In an otherwise subtle and beautifully modulated painting by Tad Okazaki, there's a small battle going on between the very intense red on the left side, and the intense blue building at the right. I often advise using strong color and values at the edges of a composition, but my advice isn't necessarily best for all pictures. Be sure that all your color and value decisions are in tune with the whole painting.

**Student Painting**

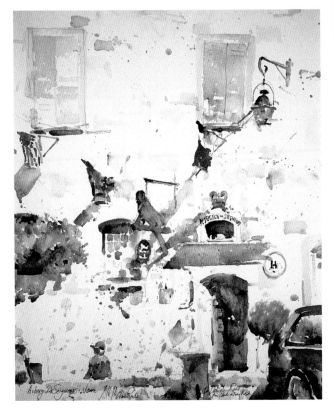

## Color Directly From the Palette

Colorful flags, cast shadows on a white building and a red car all suggested a painting of "spots of color" rather than a painting of "things." For all of these, I applied paint directly from the paint supply in order to have strong, bold color.

My colors in the door and in the cast shadows may seem complicated, but they're not. I needed both warm and cool grays. For the cooler gray, I used more Cerulean Blue or Cobalt Blue. For the warmer gray, I stressed a warmer hue such as Yellow Ochre, Raw Sienna or Raw Umber. Rather than mix the colors on the palette, I applied the colors directly from the paint supply to the paper, letting the colors mingle wet-in-wet in the cast shadows. I used firmer edges in the cast shadows and varied the values so they don't look isolated.

**Auberge de Seigneurs—Venice**
Collection of Auberge de Seigneurs

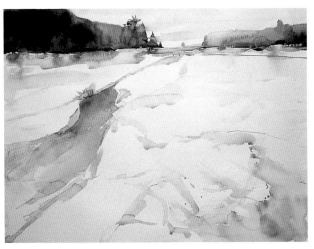

## All Is in Tune

This painting, also by Tad Okazaki, works beautifully, with wonderful lost and found edges in the distant trees. The darker values next to the side work nicely. Strong color in an otherwise subdued painting can be dangerous. Darker values can be incorporated more successfully if you include them early in the painting process and don't try to add them when the picture is near completion.

**Student Painting**

# Different Approaches to the Same Scene

Every artist will approach painting in a different way. Examine the differences between my interpretation of this bridge, and the interpretation of Craig.

**Reference Photo**
Overcast skies and even darker clouds kept coming our way.

## My Painting

This was a tough one. I wanted to keep my lights, especially the whites in the turbulent stream. My results are OK, but I wish I'd kept more of the white in the foreground stream seen in the photo. I used some opaque white to recover whites I'd lost. I thought the hill looked too drab, so I left more bits of white paper for rocks that don't appear in the photo.

I added the rocks in the water with Burnt Sienna and Cobalt Blue using fresh paint and very little water.

I used Payne's Gray, Burnt Umber, Ultramarine Blue and a touch of Cadmium Red in the hills, applying fresh paint with just enough water to keep the colors moving. Notice where the colors bleed. I painted the hill on the upper right wet-in-wet into a Payne's Gray sky.

Reference Photo

## Craig's Painting

Craig is interested in the watercolors of the neo-impressionist painter Paul Signac, a protégé of the pointillist painter Georges Seurat.

I wouldn't suggest a change in Craig's approach. It's nicely drawn, with an economy of descriptive line and shapes. I like his spots of color, all carefully considered. It's a lovely, very creative painting, filled with light even though the day was very dark.

## My Critique

Always think about where you place your darks. I think Craig could have used the darker water in the lower left to enhance his light-value rocks rather than relying on line to do the job. Perhaps the overall design of the picture would be better with a stronger dark in the upper right corner. Don't run out of steam near the margins. A dark in the upper right could provide a nice balance with the darks in the lower left water, creating a diagonal path through the painting.

# Different Approaches in Technique

I think you should not only admire, but also learn from painters who don't paint or think like you. Bob Parker does everything I don't do. He paints an undertone over the whole paper; in this painting, it shows the trenches and fields below the aircraft. I always paint the subject first, then add the surroundings. My approach works well with a subject that takes up most of the picture, but here the subjects (the two aircraft) take up only a small part of the picture space. The painting wouldn't have worked nearly as well using my approach. I would have had a tough time painting the land below for fear of ruining a picture of two decently painted airplanes.

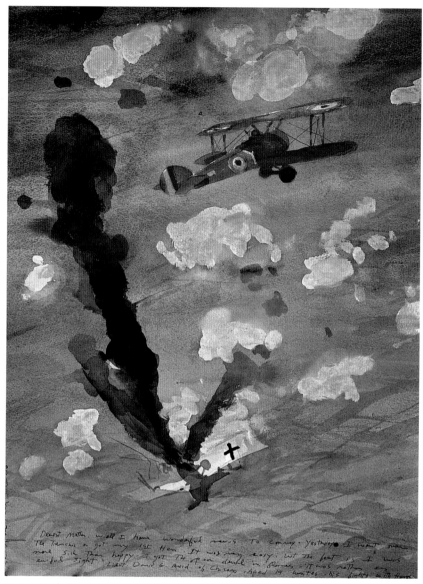

## Using Both Transparent and Opaque Watercolor

I have several favorite contemporary painters, but Bob Parker has long been on my "most favorite" list. This painting was inspired by a letter my father sent to my grandmother, which was later published in a Chicago newspaper. In the letter, my father described his first victory as a fighter pilot in the Royal Flying Corps during World War I.

Bob used opaque pigments over transparent washes on my father's Camel aircraft. I think he must have used a template to save the light-value wings of the unfortunate downed aircraft. The opaque white puffs aren't clouds, but British anti-aircraft shells exploding. The smaller black puffs are exploding German shells. I've often wondered why my father was experiencing so much friendly fire.

The opaque paint is a bit unusual. Many watercolor societies have "purist rules" saying that one must never use opaque color. (This is odd, since both Winslow Homer and John Singer Sargent used opaque color.)

**Lt. D. G. Reid's First Victory**
Robert Andrew Parker

# Conclusion

## On Colors and Pigments

Except for Payne's Gray and Ivory Black, I use mostly variations of primary colors in my mixes.

The red family: Carmine and Permanent Alizarin are basically the same. Depending on the subject, I use Burnt Umber, which is darker, earthier and less transparent than the others, or Burnt Sienna, which is warmer.

The blue family: I choose my blues not according to hue or temperature but because of their relative values. For a lighter area, I'd choose Cerulean Blue; for a mid value, Cobalt Blue; and for a darker area, Ultramarine Blue. Winslow Homer seemed to use only Antwerp Blue. I use that for painting shallow water in the Caribbean or Florida or in swimming pools.

The yellow family: I usually choose an earth yellow for my mixes, again, according to the value I am after—Yellow Ochre or Raw Sienna for lighter areas, and Raw Umber for darker areas.

I find Cadmium colors difficult for mixing, except for a few cases. I rarely use any of the Cadmium Yellow variations in my basic mix except in mixing some greens and skin tones. I use Cadmium Red or Vermilion only in mixes for a red object or in light complexioned skin tones. I use Cadmium Orange along with Carmine or Permanent Alizarin to enliven and warm very light lights, such as flowers or a beach. Also, Cadmium Orange makes a nice light gray when mixed with Cerulean Blue.

Greens are difficult, and I've tried most of them. The only permanent greens are Viridian and Oxide of Chromium. Decide what tube greens work for you. Experiment with various Cadmium Yellow variations and earth yellows mixed with one of the blues.

I am always intrigued with anything John Singer Sargent did. His only tube green was Viridian and his only earthy yellow was New Gamboge. He also used Cadmium Yellow, Cobalt Blue and Ultramarine Blue, so his wonderful greens are a combination of two or more of those.

Payne's Gray is handy for cloudy skies. I do use Ivory Black, usually mixed with Ultramarine Blue for a cool and lively black, or with Burnt Sienna or Burnt Umber for a warm black. Don't use it to darken or contaminate other colors.

In the end, you need to find which colors work best for your paintings. Good luck. I hope you've picked up some hints in this book. Enjoy your painting.

# Index